ART NOW

ART NOW

EDITORS **BURKHARD RIEMSCHNEIDER UTA GROSENICK** AUTHORS **LARS BANG LARSEN CHRISTOPH BLASE YILMAZ DZIEWIOR JEAN-MICHEL RIBETTES RAIMAR STANGE SUSANNE TITZ JAN VERWOERT ASTRID WEGE**

TASCHEN

KÖLN LONDON LOS ANGELES MADRID PARIS TOKYO

CONTENTS

PREFACE

"Art Now" is the most up-to-date publication to offer an authoritative overview of art and artists of the 1980s and 1990s onwards. Totalling 192 pages and covering the work, careers and credos of 87 artists, it is lavishly illustrated with over 300 reproductions and features pithy introductory commentaries by a team of seven experts.

Contemporary art is taken to mean work by artists whose active output, barring a handful of exceptions, goes back no more than twenty years and is still evolving. The youngest of the artists featured have been exhibited internationally for only a year or so. All of the artists featured come from the West; it proved impossible to cast a global net, so in the present volume other cultural provenances have not been represented. "Art Now" is not just a retrospective of two highly productive and invigorating decades; it focuses on the future. In reviewing the art of the 1980s, for example, it relates the history, then traces influences forwards into the 1990s and beyond. In one sense the past may be over, but in another it is actively present, as each new artistic idiom is adopted and adapted from predecessors. In that sense, and in that spirit, now that the 1990s too have slipped into the past, "Art Now" looks to the new millennium and asks what may await us on the art scene in the decade ahead.

A publication such as this cannot create or manipulate trends in art, nor can or should that be its aim. Our purpose is solely to review recent and current developments that have been showcased in galleries, which now play the central part in advancing and communicating new art. Movements and trends in art exist within a public space, and the market that influences their form and content cannot be ignored. Art is, of course, always in a state of flux, and in producing "Art Now" we had to confront the difficulty of communicating it in book form. Much of that difficulty has to do with the limitations of the book as medium. When an artwork incorporates movement or sound, when it is interactive in conception or uses a multimedia approach, it is beyond the reach of the book: it can only be reproduced statically, shorn of its atmosphere.

A fundamental principle of this publication from its inception has been to forgo value judgements and pigeon-holing. These may have their place in reviewing the art of the past, but it would be premature and presumptuous to preempt the verdict of posterity. Instead, "Art Now" is conceived as a guide, and the artists are presented in alphabetical order. This seemed preferable for a number of reasons.

– First, a linear or chronological approach would be unlikely to illuminate the sheer vitality and diversity of the many kinds of artistic phenomena that now co-exist on the art scene.

– Second, art broadened its scope in the 1980s and 1990s, unembarrassed at crossing borders into neighbouring areas such as design, the media, advertising, architecture, cinema, theatre, dance and music. Art can have a social agenda, it can be about communication; some believe it has therapeutic values and functions, while others deny it any societal role and insist on the autonomy of art. The positions adopted are many and various.

– And, third, "Art Now" is primarily intended as a guide to an imaginary exhibition, where each artist has been allocated the same amount of space and his or her position determined purely by alphabetical chance.

The works chosen for this imaginary exhibition highlight the attitudes and strengths of each artists. They were selected in consultation with the artists themselves or with their galleries. The layout of the pages treats every body of work as a unit, and attempts to approach each artistic personality on its own terms. "Art Now" is full of diverse information. As well as reproductions of works, commentaries and statements, there are photographs of the artists (where they agreed to this). A glossary at the back of the book defines key words, concepts and technical terms.

Inevitably the selection is a subjective one, despite all our efforts to cast an objective eye over the inter-national art scene. Even so, we feel that this overview is fair and representative, and will enable users of the guide to form some idea of where art is heading at the beginning of the new millennium.

PREFACE

Our thanks are due first and foremost to the artists, without whose support this book would not have been possible. We also wish to thank Andy Disl, who handled the graphic design of this substantial publication; and all at Taschen who worked so hard on this project, most particularly Yvonne Havertz and Nina Schmidt (editorial) and Ute Wachendorf (production), and our authors, Lars Bang Larsen, Christoph Blase, Yilmaz Dziewior, Jean-Michel Ribettes, Raimar Stange, Susanne Titz, Jan Verwoert and Astrid Wege.

We would also like to thank the galleries, museums, institutions and individuals who generously made available the excellent illustrative material and gave us their invaluable assistance and advice.

Uta Grosenick and Burkhard Riemschneider

ARTISTS

FRANZ ACKERMANN

1963 born in Neumarkt St. Veit, Germany / lives and works in Berlin, Germany

"What is conveyed is not the touristic minutiae of where and how but rather a kind of distilled travel record. This feeds on recollection and present experience."

Franz Ackermann demonstrates that artistic concern with the present can be handled not only in photography, film, Conceptual and installation art, but also in painting. In large-scale, sometimes expansive paintings, he operates suggestively with our perception of the outside world, its association-laden structures, colours, forms, illusions and clichés. The central source of experience in Ackermann's work is travel. He began to develop as a painter in the early 1990s during a one-year stay in Hong Kong. Further trips to Asia, South America and Australia followed. Initially he made "mental maps" – little pocket-size watercolours that already indicate Ackermann's interest not in copying, but in mentally absorbing these cultural regions. Back in the studio, he worked up paintings that carried over cartographic drawings into exploded projections. Since 1997, Ackermann has been working increasingly with the totality of painting. Individual paintings are drawn together by the contours of the space or applied direct to the walls, linked up in a spatial panorama like an endless film loop. In the project "Songline", 1998, he designed a transportable space module that circles round and draws in the viewer. Photos originating from travel advertisements and the daily press, which convey the media's view of the world and its problems, are reflected

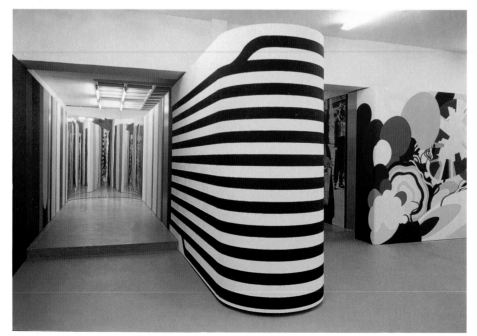

01 **"SONGLINE"**, installation view, Neuer Aachener Kunstverein, Aachen, Germany, 1998.
02 **UNTITLED (MENTAL MAP: EVASION III)**, 1996. Oil on canvas, 280 x 285 cm.

in mirrored surfaces. The fascinating critical dimension of these recent coordinates of experience has been present in Ackermann's approach from the start. Now, however, it is placed in spatially, politically and visually demanding confrontations that challenge the viewer to respond. S. T.

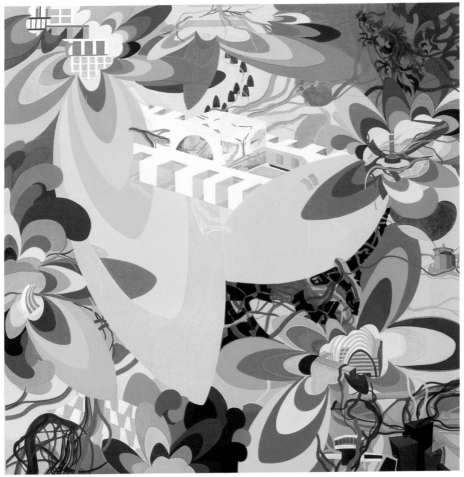

EIJA-LIISA AHTILA

1959 born in Hämeenlinna, Finland / lives and works in Helsinki, Finland

Since the mid-1990s, Eija-Liisa Ahtila has been as much in evidence at international film festivals as on the art scene. She has always deliberately shown her films and videos in various different contexts. The same work, for example, may be shown in a 35 mm version in the cinema or video-projected to create large spatial installations in the gallery. On one occasion, three 90-second works were screened both on monitors that stood casually on tables in an art exhibition, and between commercials on television. In terms of content, Ahtila always comes back to the theme of relationships – between generations, between the sexes and with herself. Her stories, which often run in parallel using several split-screen images, appear to be authentic reportage, but in fact the dialogues derive from Ahtila's own experience and research, played out as fictitious narrative sequences by actors. The soundtrack is Finnish with English subtitles. In her to date best-known work "If 6 was 9", 1995, a group of young girls talk about their experiences. Accompanying the question "What should you do when every cool guy offers you his body?" are three images. In the central one a girl plays the piano; on the right, she smiles flirtatiously, and on the

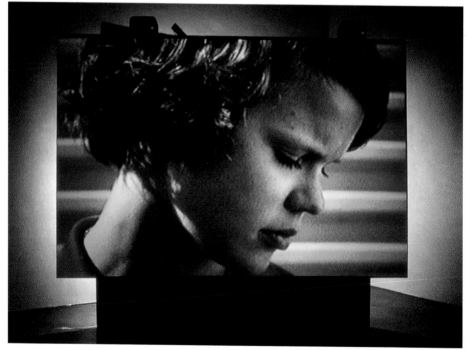

left she is flipping unenthusiastically through a magazine. Ahtila lets her subjects relate both their positive and negative experiences in a natural way that is neither sensationalist nor coy. They might as well be talking about playing the piano or basketball as discussing sex. The world is packed with information, Ahtila seems to suggest. Before experiences come, one has already learnt all about them, so what is there to get excited about? C. B.

01 / 02 **TODAY,** 1996/97. 35 mm film and DVD installation for 3 projections with sound, 3 wooden screens, paint, 10 mins.

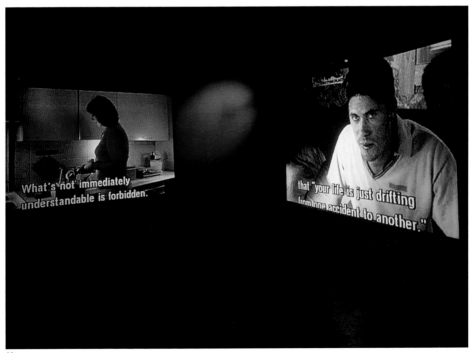

KAI ALTHOFF

1966 born in Cologne / lives and works in Cologne, Germany

Kai Althoff's first exhibition, held in 1991, took the form of a happening, and bore the title "Eine Gruppe von Befreundeten trifft sich in einem Ladenlokal auf dem Friesenwall, Köln, um Masken herzustellen" (Some friends meet in a Cologne pub to make masks). Many of his installations, drawings, videos, collages and performances evoke memories of childhood and youth, mainly owing to the materials and methods he uses. For instance, he draws with felt pens, makes figures in clay, or, as in the installation "Modern wird lahmgelegt" of 1995, creates free-standing sculptures from cardboard. In the short text accompanying this work, Althoff explains that two of these figures are film stars from the 1930s, who are being watched through the window by a third, a Nazi stormtrooper. In many of his exhibitions, these quasi-literary texts contain references to the associations he has in mind, making it easier to interpret the works on display. His protagonists are often linked with social or political events. Althoff has also staged performances with his artist colleague Cosima von Bonin, later using the scenery and props as exhibits. Equally important is his membership of the "Workshop" band. He designs their CD and record sleeves, and the fictitious names in his exhibitions often crop up in the group's lyrics. Neither his works nor the "Workshop" pieces can be clearly pigeon-holed to one particular style, despite occasional echoes from the 1970s. In both areas, Althoff conjures up independent worlds in which his memories and inventions intermingle. Y. D.

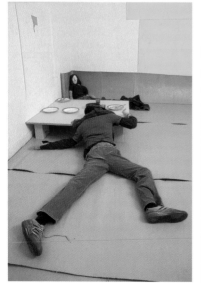

01 REFLUX LUX, 1998 (details). Installation views, Galerie NEU, Berlin, Germany, 1998. **02 UWE: AUF GUTEN RAT FOLGT MISSETAT,** 1993. Coloured pencil on paper, c. 30 x 20 cm.

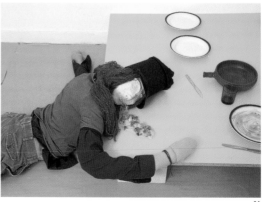

NOBUYOSHI ARAKI

1940 born in Tokyo / lives and works in Tokyo, Japan

"I do not claim that my photos are true ..."

Nobuyoshi Araki has published some hundred photo albums in the space of 30 years. He became famous through his first work "Un Voyage sentimental", which he and his wife Yoko published in 1971. This photographic series shows a succession of banal moments, intimate situations and passing days during their honeymoon. Yoko is pictured sitting in a train, in a hotel room, sleeping, or having an orgasm. An insignificant street scene is photographed from the hotel window, or the platform of a provincial railway station is documented. This systematic exposure of Araki's private life reached its climax in 1990 with the death of his wife, which yielded the material for a further album. Araki manically photographed every moment of each day: Yoko sitting at a table, lying in bed, stepping out on to the street or looking up at the sky. The photographs that have become emblematic of Araki's work, however, are his portraits of young women – prostitutes and schoolgirls – either dressed or naked, hanging from the ceiling or thrown to the ground, their hands tied together, their legs apart, or even engaged in the sexual act.

01

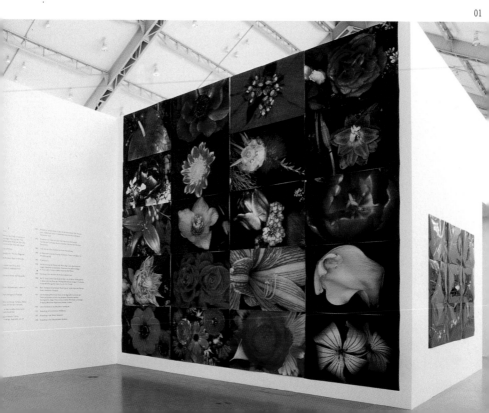

But these works are not so much intended to examine the eroticism of submission as to explore an aesthetic of fictitious truth. They show women who remain untouchable despite their subjection, despite the ropes and the pain. They are putting on an act, and only too often their gaze – rendered erotic by the camera's presence – confronts the viewer with a dispassionate arrogance. The vast number of pictures and publications produced by Araki indicates that, for him, the act of photography represents an everyday business like eating or sex. They reveal, both in their triviality and their vitality, the intimate and mundane nature of the passage of time. This breathtaking amassing of photos touches on the deeper meaning of an art that is totally synchronised with the duration of life as it is lived. J.-M. R.

02

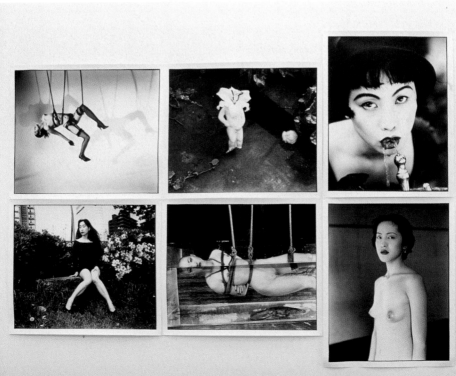

MATTHEW BARNEY

1967 born in San Francisco (CA) / lives and works in New York (NY), USA

"The forms don't really take on life for me until they've been 'eaten', passed through the narrative construction."

Matthew Barney stages timeless fictions in the form of hybrid installations, filmed performances and stylised videos. Barney's works are peopled by artfully made-up, extravagantly dressed models, mutants padded out with cushions, unidentifiable shapes made of synthetic material, a greasy slime made of Vaseline, roaring racing cars and horned satyrs. Overcharged with imagination, the effect of the art worlds conjured up by the one-time medical student is both epic and aseptic. Of his work to date, the high point is the "Cremaster" series of five films, four of which ("Cremaster 4", 1994, "Cremaster 1", 1995/96, "Cremaster 5", 1997 and "Cremaster 2", 1999) have been made so far. The first of these takes place on the Isle of Man, where the celebrated Tourist Trophy Motorbike Races have been held every year since the 1960s. The races form a central motif of the film. The second film shows a football stadium over which two airships float, while the third takes us to the Budapest of the past, with the Chain Bridge, baroque opera house and Art Nouveau baths. "Cremaster 2" was filmed on an ice field in Canada, while the as yet unrealised "Cremaster 3" is due to be shot in the Chrysler Building in New York and shown in the Guggenheim Museum shortly. Barney's approach is always the same: first the approximately hour-long video is played in public cinemas, then large installations, objects, photos and drawings from the relevant imaginary world are displayed in museums and galleries, and at the same time an art book containing the pictures from the film is published. The title of the series is derived from the cremaster muscle in the male genitals from which the testicles are suspended, and which is retracted in a reflex movement produced by cold or fear inside the body.

J.-M. R.

01 02 03 ►

01 CREMASTER 4, 1994. Production still.
02 CREMASTER 5, 1997. Production still.
03 THE EHRICH WEISS SUITE, 1997 (detail). Acrylic, prosthetic plastic, vivak, pyrex, internally lubricated plastic, sterling silver, c-prints and gelatin silver print in acrylic frames, graphite, acrylic and petroleum jelly on paper in acrylic and prosthetic plastic frame, Jacobin pigeons.

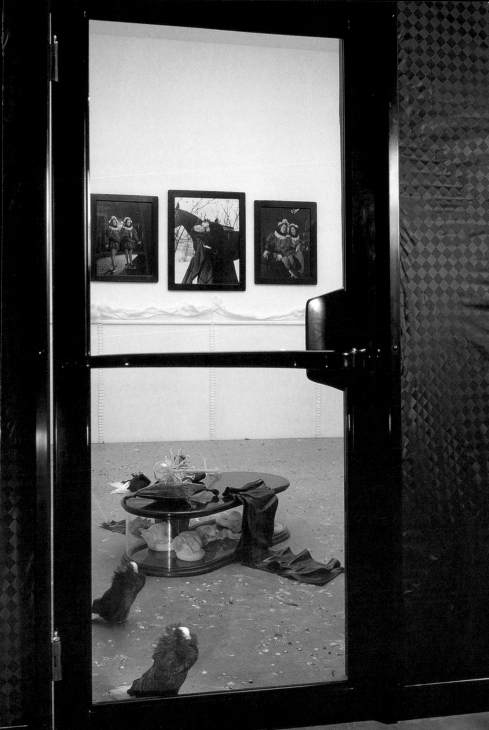

VANESSA BEECROFT

1969 born in Genoa, Italy / lives and works in New York (NY), USA

"I am interested in the difference between what I expect and what actually happens."

Since the mid-1990s, Vanessa Beecroft has been parading before us a succession of scantily clad girls. Recently, they've been appearing with nothing on at all. In Beecroft's performances and exhibition openings they silently take up their positions, moving very little, standing before the public like living pictures. Remaining as evidence of these events are polaroid photographs and videos, which Beecroft calls "the least interesting part for me" – for documentation only comes alive with the idea that one might have been present oneself. Wholly in keeping with current cultural trends, Beecroft is offering something that obviously cannot be conveyed through the media. And yet she is playing in her mind with the very images communicated by the media. Some of her ensembles of girls and women recall Pippi Longstocking, while others bring to mind Helmut Newton's coolly posed compositions, or fashion shows and theatrical or filmic scenes. But there's little indication which of these associations comes closest to Beecroft's intentions. The girls are usually all dressed and made-up in exactly the same way so that their individuality seems to be blotted out. In one performance they may appear vulnerable, in another, impressively strong. There is a charged and yet restrained atmosphere created by the tension between broken taboos and ancient ideals of beauty, between eroticism and the charm of naked shop-window dummies. Neither the models nor the public show any emotion; what is going on in their imaginations is a total mystery. No comment is made. The participants all have their own ideas and perceptions, but they keep them to themselves.

C. B.

01 PERFORMANCE-DETAILS, Stedelijk Van Abbemuseum, Eindhoven, The Netherlands, 1996. **02 PERFORMANCE-DETAILS,** Deitch Projects, New York (NY), USA, 1996.

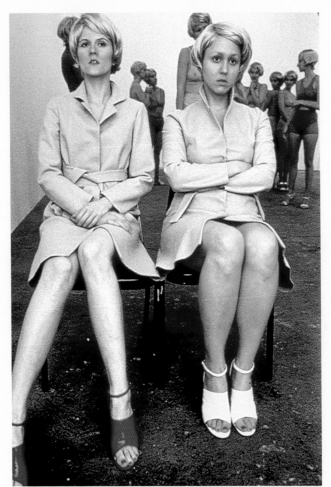

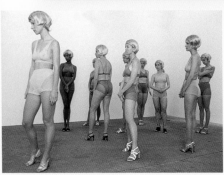

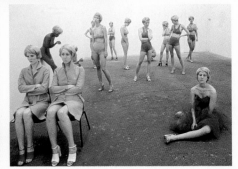

COSIMA VON BONIN

1962 born in Mombasa, Kenya / lives and works in Cologne, Germany

Cosima von Bonin's works have their origin in the creative tension between private, subjective values and social concerns. Among her themes in her installations, objects, films and videos are the discursive associations and external influences that give rise to her works. These include other artists and her immediate social environment, along with her own personal experiences. It was an approach already evident in her first exhibition (1990), in which she showed balloons inscribed with the names, dates of birth and debut exhibition dates of the artists represented in Harald Szeemann's legendary exhibition "When Attitudes Become Form", 1969. The "first exhibition" theme is thus taken as a biographical point of departure, and related to recent art-historical events. Von Bonin often uses her own exhibitions as a forum for the presentation of works by valued friends and colleagues, which in turn leads to social events such as concerts, film evenings, discussions and exhibitions. Her open-handedness in fact challenges the mechanisms of art presentation, creating a crossover between the visual arts and other artistic activities. She has often put on joint performances with Kai Althoff, exhibiting the props and fittings in an accompanying show. Her most recent installations ("Löwe im Bonsaiwald" [Lion in the Bonsai Forest], 1997, for example) often have a theatrical atmosphere enriched with private metaphors which defy rational explanation and specific classification, in spite of the many clues provided. Y. D.

01 INSTALLATION VIEW, Villa Arson, Nice, France, 1997. **02 HAST DU HEUTE ZEIT – ICH ABER NICHT.** Installation view, Künstlerhaus Stuttgart, Stuttgart, Germany, 1995 (with Kai Althoff). **03 "LÖWE IM BONSAIWALD"** (details), installation views, Galerie Christian Nagel, Cologne, Germany, 1997.

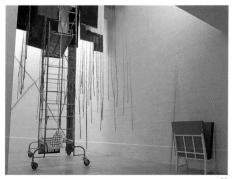

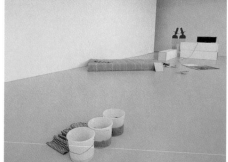

01

02

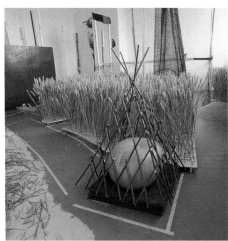

03

ANGELA BULLOCH

1966 born in Fort Frances, Canada / lives and works in London, England

"The viewer is a collaborator in the sense that she defines or perceives meaning in her own terms."

The big, coloured spheres of light work like signals. You can't help trying to fathom the system that makes them go on and off, and to understand its meaning. Some of these light installations are triggered by movement, others by music; several follow a rhythm of their own. You find yourself exposed to a stimulus and you respond to it with a reflex, whether by turning your gaze on a particular sphere at a certain moment, or by repeating your movement to trigger off the mechanism again. This principle of rewarding the viewer for a trivial action is typical of Angela Bulloch's approach, and since the early 1990s has continually found new forms of expression. Sometimes you're required to take a seat on a simple bench, which sets off a sequence of noises, or causes a painting machine to start drawing on the wall, or a computer game to begin. Other installations work with hidden contacts on the floor, where large round cushions invite you to stay. Then there are the seemingly incongruous inscriptions on the wall or the floor that contain rules of conduct from different areas of life. This "Rules Series" confirms that Bulloch is concerned with systems governing human behaviour. A complex world needs rules in order to function, but these should always demonstrate their purpose in an atmosphere of tolerance and reason. This idealistic sense of social concord is a constant theme in Bulloch's installations. Thus she presents something in the context of art that is only too often counteracted in everday life. C. B.

01 MAT LIGHT (GREEN, RED, BLUE), 1997. Installation view, "Superstructure", Migros Museum für Gegenwartskunst Zürich, Zurich, Switzerland, 1998. **02 BETAVILLE,** 1994.

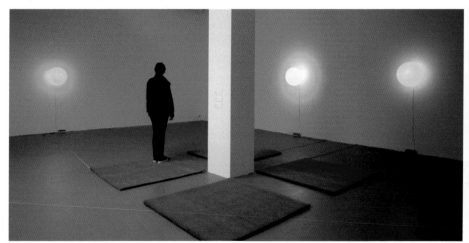

01 / 02 ▶

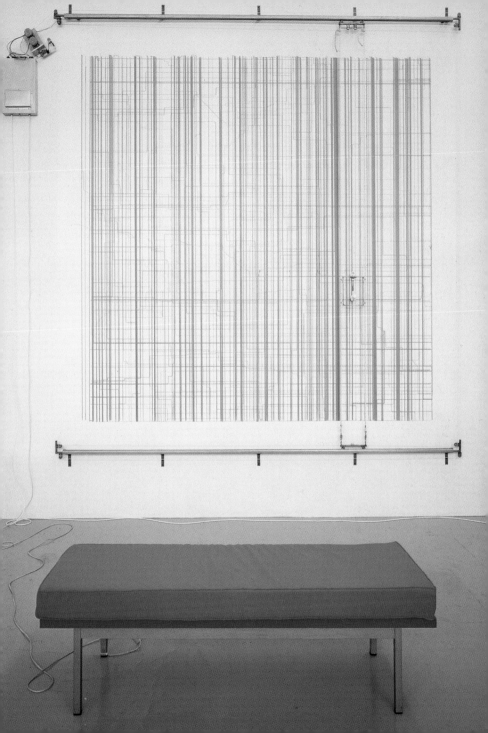

MAURIZIO CATTELAN

1960 born in Padua, Italy / lives and works in New York (NY), USA

"I think that the real situation that has to be unhinged is the interior one: the more my work turns to the exterior, the more I believe I talk about my problems and my interior."

In a subversive and humorous way, Maurizio Cattelan manages to breach the rules of the art world, delivering ironic comments on socially controversial subjects. Racist tendencies in Italy or the influence of the Mafia are just as likely to provide the themes of his occasionally interventionist work as intrinsically 'artistic' topics are. Since he is skilled at exploiting the workings of the art business, his methodology is often described as "parasitic". In one work, for example, he gave his place in an exhibition to a perfume manufacturer, who used it to display a poster advertising his products. Cattelan often uses symbols representing escape from the exhibition, in the form of knotted bed sheets, for instance, or a big hole dug in the gallery floor. It is against this background that his portraits should be interpreted. These were drawn by a police draughtsman from descriptions of Cattelan's friends and relatives; the resulting works resemble mug shots of criminals. Cattelan is adept at using simple means to register his objections to exhibition conditions. Invited by the Vienna Secession to organise a show in their basement, he installed a pair of bicycles, which were pedalled by two invigilators whenever a visitor entered, to generate the meagre light of a 15-watt bulb. The point was not only to make a critical comment on the low, windowless cellar rooms but also to embarrass the viewer, since the staff only had to activate the dynamos when someone came into the room. In this way, Cattelan creates convincing symbols for the hierarchies and dependencies of the art world. Y. D.

01 LITTLE SPERMS, 1997. Painted latex, 10 x 5 x 5 cm (each). **02 LOVE LASTS FOREVER,** 1997. Skeletons, 210 x 120 x 60 cm. Installation view, Skulptur. Projekte in Münster 1997, Münster, Germany, 1997.

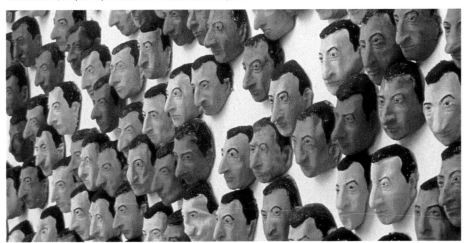

01

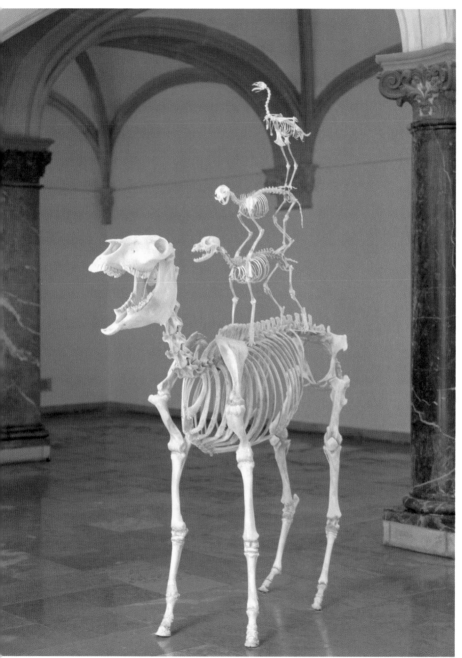

JAKE & DINOS CHAPMAN

Jake Chapman **1962** born in London. Dinos Chapman **1966** born in Cheltenham, England
Both live and work in London, England

"We are sore-eyed scopophiliac oxymorons … We are artists."

The Chapman brothers' life-sized resin and fibre-glass figures appear realistic at first sight. Only from close up can the viewer tell that they are hermaphrodites with all sorts of genetic anomalies manifested in absurd combinations of arms, heads, legs and torsos, with the nose, ears or mouth replaced by an anus, a vulva or an erect penis ("Fuck-face", 1994, "Cock-shitter", 1997). These fantastic biological growths are not only upsetting but hold a certain fascination, though we may not like to admit it. And it is exactly the ubiquitous sex organs that make these almost child-like figures incapable of reproduction. The obscene creatures, unrestrained and full of irony are the products of an inner convulsion, a transgression. They are not clones but unique biological entities. Jake and Dinos Chapman's human figures are not meant to glorify aberration; they are simply assemblages with endless possible permutations. Unlike Sol LeWitt and Carl Andre – artists to whom they make frequent references – the Chapman brothers take the parts of the human body rather than geometric abstraction as their starting point. They see their monstrous creations as puzzles, mathematical variations, an ironic combination of wordplay and bad taste. The stated cynical intent of the two artists is to attempt to reach a cultural value of nil, to create an aesthetic of insensitivity and indifference. Therein lies the tragic dimension of their œuvre. J.-M. R.

01 ZYGOTIC ACCELERATION, BIOGENETIC, DE-SUBLIMATED LIBIDINAL MODEL (ENLARGED X 1000), 1996. Fibreglass, resin,
paint, artificial hair. 02 FOREHEAD, 1997. Fibreglass, resin, paint, artificial hair, shoes, 135 x 60 x 45 cm. 03 TRAGIC ANATOMIES, 1996 (detail).
Installation view, "Chapmanworld", Institute of Contemporary Arts, London, England, 1996.

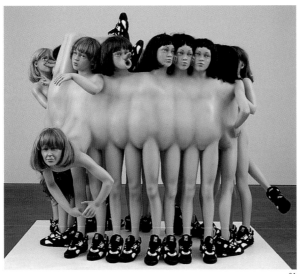

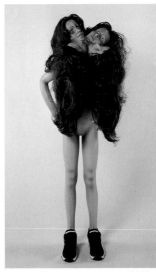

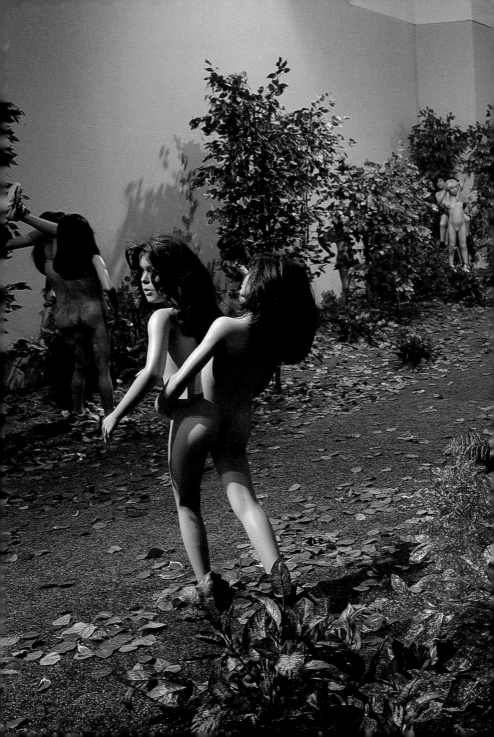

JOHN CURRIN

1962 born in Boulder (CO) / lives and works in New York (NY), USA

"Life presents itself to me in those kinds of terms: staring at women, staring at the sky, staring at something."

John Currin's earliest paintings include a series of portraits of young girls based on photos from a high-school yearbook. The pupils of the girls' eyes are black discs, giving their gaze a dull, empty expression; the blank faces permit no interpretation of their character. In a subsequent series, Currin painted a group of older, strikingly thin women who assume the poses of models. Both grotesque and touching, these portraits convey a sense of the longings of the ageing women dressed in tight-fitting, youthful clothing. Currin is not concerned here with an ironic exposure of his subjects, but with analytical observation. In his pictures of couples, young women gaze respectfully up at middle-aged male dandies in flashy, vulgar clothing. There is evidence in these works that Currin is less interested in the representation of individual personality than in dealing with stereotyped clichés. Later series featured women with huge breasts, their torsos and hands emphasised by thick brush strokes ("The Bra Shop", 1997, for example). Currin restricts himself almost entirely to this caricatured realism, though he borrows poses from Botticelli's paintings or presents the sky in the style of a Rococo painting. Given the virtuosity of his painting technique, it is also clear that Currin has a pronounced interest in the long tradition of painting and is confidently attempting to find a slot for his pictures in it.

<div align="right">Y. D.</div>

01 THE NEW GUY; AUTUMN LOVERS; NUDE; BLONDE NUDE; NUDE WITH BLACK SHOES; THE OLD GUY, all 1994 (from left to right). Oil on canvas. Installation view, Galerie Jennifer Flay, Paris, France, 1994. **02 ANN-CHARLOTTE,** 1996. Oil on canvas, 122 x 97 cm.

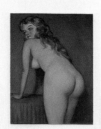
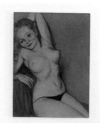
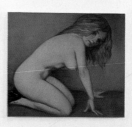

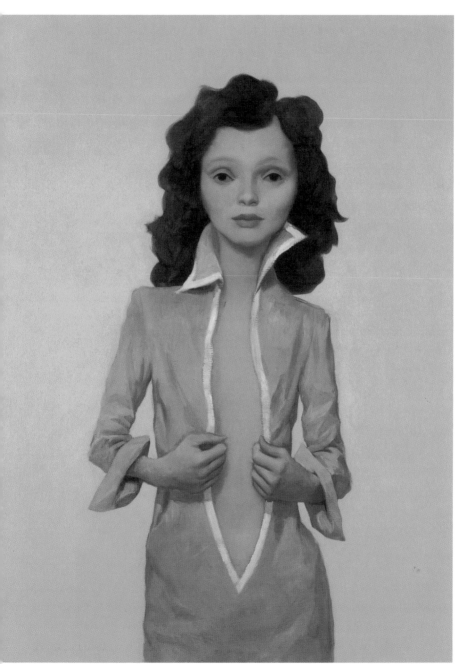

WIM DELVOYE

1965 born in Wervik, Belgium / lives and works in Ghent, Belgium, and London, England

"I am a tennis player, playing on both sides of the net,
and I guess that this is true for everything I have done so far."

The eclectic art of Wim Delvoye seems to be aimed above all at making us laugh. A football goal in leaded glass and another in porcelain, a concrete mixer carved in wood and a tiled floor with faecal motifs, bricks with baroque decoration all take the viewer by surprise. There is both frustration and irony to be found in a gas cylinder and circular saw made of Delft faïence, velvet-lined containers for bucket and spade, tattooed pig-skins, a fountain in the form of an angel turning round and urinating in the wind, ironing boards decorated with blazonry, a urinal crowned with the framed picture of the king of the Belgians. Delvoye's objects can be read as *bon mots*, and what even the most ordinary, hackneyed and vulgar have in common that they are all the products of considerable craftsmanship, resulting in a highly developed form of popular art. While reverting to the craft tradition only in order to defy any particular development of taste, Delvoye's art attempts to reconcile the middle-class penchant for kitsch through popular humour. His works break the taboos of the avant-garde, who systematically renounce beauty in execution, every form of craftsmanship and every aesthetic concession to bourgeois taste. Delvoye recalls the power of paintings and the richness of Baroque ornamentation, and would rather go along with the unshakeable tenets of Catholicism than with Protestant theology. For him, art, good taste and aesthetics are all signs of the decline of a civilisation that has long since broken up and been supplanted. The Fleming sees himself first and foremost as a provincial artist who wishes to explore the foundations of his own culture, and as someone whose pleasing decorations will, he hopes, brighten up life in his country, where Modernism has no place. J.-M. P

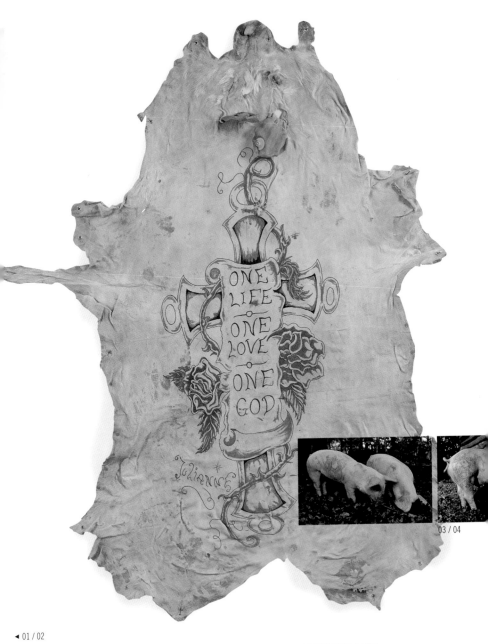

01 MUM, KEYS ARE . . . , 1996. Laser ink jet paint on canvas, 300 x 400 cm. **02 TATTOOED PIG SKIN (JULIANNE),** 1995.
Tattooed pig skin, c. 150 x 110 cm. **03 / 04 PIGS,** 1994–1997 (details). 4 live tattooed pigs. Installation views, Open Air Museum
of Sculpture Middelheim, Antwerp, Belgium, 1997.

THOMAS DEMAND

1964 born in Munich / lives and works in Berlin, Germany, and London, England

"I think photography is less about representing than constructing its objects."

Thomas Demand explores photographs as visual traps. In his pictures, an office, a staircase or a motorway bridge are not what they seem. They do not show anything real, but structures of paper and cardboard. Without recognisable dimensions, they appear genuine at first because they are meticulously constructed, but, devoid of human figures, signs and language, their very immaculateness soon betrays them as fakes. The piled-up cardboard boxes have nothing printed on them and the sheets of paper on the desk are blank. Demand builds these models only for the purpose of photographing them, never including them in his exhibitions. The photos impress through their abstract, formal composition and colour, displaying perfect photographic solutions. The statement made by his subjects cannot be reduced to a common denominator. They denote the typical dull, grey aesthetic of modern administration – the office, the civic building, the landing. And in the end, the allusion seems so familiar that the question arises as to an authentic document, a real basis for the model. These bases do exist: biographical places ("Ecke", 1996), sites rich with history ("Archiv", 1995), or crime scenes ("Flur", 1995), chosen deliberately by Demand from historical, political and criminological documentary photographs. However, in the last few years he has refused to identify his sources, claiming that knowledge of these would only restrict interpretation of his work.

S. T.

01 STUDIO (STUDIO), 1997. C-print, diasec, 184 x 355 cm. **02 SPRUNGTURM (DIVING BOARD),** 1994. C-print, diasec, 150 x 120 cm.

01

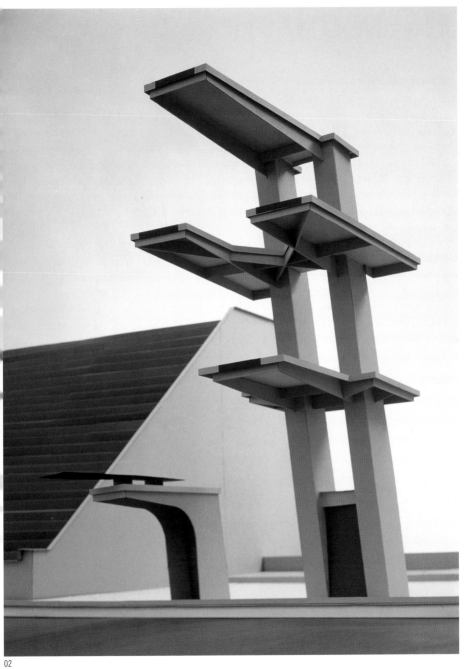

RINEKE DIJKSTRA

1959 born in Sittard, The Netherlands / lives and works in Amsterdam, The Netherlands

"I am not concerned with the way people think about themselves. I should like to show a particular intensity, a particular tension, that is present in themselves."

Rineke Dijkstra makes photographic portraits of teenagers and young adults in the Netherlands – her home country – as well as in Poland, England, Portugal and the USA. Starting out as a professional photographer, she produced various series that through the early 1990s steadily gained in artistic form and now go far beyond social documentation. The first in the series was "Beaches", 1992–1996, on the theme of young people on the beach. They were photographed from various spots, but the camera always points towards the sea. Dijkstra's subjects approach the viewer so directly that their insecurity is legible on their faces and bodies. Despite the tell-tale characteristics of dress and hairstyle, they retain their own individual mystery. By her choice of subjects and naming of their home towns, she raises questions of identity, but does not answer them – either in the case of the girls in an English disco or their presumed college counterpart, or in the juxtaposition of two photographs of the same woman taken in rapid succession. The photographs do not encourage direct identification with their subjects, for Dijkstra keeps them in a distant perspective. In her choice of subjects she aims at a particular element that catches every eye: all the people she has photographed – whether teenagers, young bull-fighters or women who have just given birth – are vulnerable, sensitive individuals in a stage of transition. This situation is reflected in their insecurity, their pose, their dress, even their skin. In Dijkstra's recent switch to video, a temporal dichotomy arises: a period of real time in addition to the fixed time of the photographic camera, and under scrutiny this takes on the profundity of a behavioural study. S. T.

01 / 02 / 03

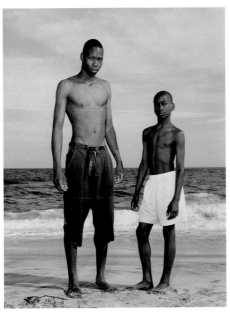

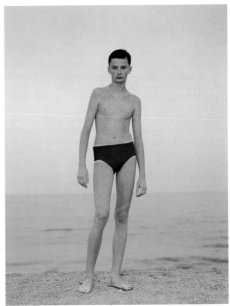

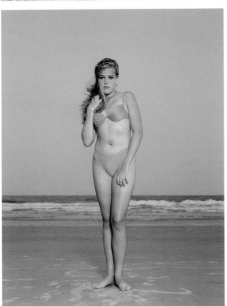

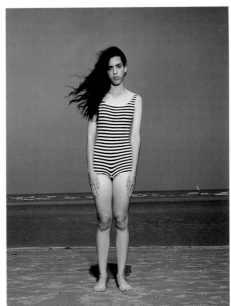

01 THE NUGENT, R. C. HIGH SCHOOL, LIVERPOOL, ENGLAND, NOVEMBER 11, 1994. 02 MONTEMOR, PORTUGAL, MAY 1, 1994.
03 VILLA FRANCA, PORTUGAL, MAY 8, 1994. 04 LONG ISLAND, N. Y., U. S. A., JULY 1, 1993. 05 ODESSA, UKRAINE, AUGUST 4, 1993.
06 HILTON HEAD ISLAND, S. C., U. S. A., JUNE 24, 1992. 07 DE PANNE, BELGIUM, AUGUST 7, 1992.

MARK DION

1961 born in New Bedford (MA) / lives in Beach Lake (PA), USA, and works worldwide
"Taxonomy, i. e. the classification of the natural world, is a system of order imposed by man and not an objective reflection of nature. Its categories are actively applied and contain the assumptions, values and associations of human society."

According to Mark Dion, "nature" is a cultural construct. It is, as the quotation (see above) for his portrait of the nature researcher Georges Cuvier – "Taxonomy of Non-endangered Species", 1990 – makes clear, a projection area for human notions. Dion approaches the question of the representation of nature from different angles. In doing so, he often links up with the historical moment in the late 17th and early 18th centuries when the subjective arrangement of the cabinet of curiosities gave way to the rational organisation of the museum. The natural history museum therefore takes on a central role in his work as the scene of those new systems of classification. The scientific processes of nomenclature and categorisation are also always acts of control, and in this they follow the dominant ideology of their time. Whereas works such as "Extinction Series, Black Rhino with Head", 1989, saw the threat to the environment and to the abundance of species as a result of colonialism and industrialization, Dion's installations from the early 1990s onwards deal with the politics of representation, especially in the museums. In his role as a nature and field researcher Dion treats this problem in such works as "On Tropical Nature", 1991, "A Meter of Meadow", 1995, or "A Tale of Two Seas: An Account of Stephan Dillemuth's and Mark Dion's Journey along the Shores of the North Sea and Baltic Sea and What They Found There", 1996. With ironical exaggeration, Dion adduces the processes of collecting, curating, presenting and recording, and he carries current classification systems ad absurdum.

A. W.

01 THE DEPARTMENT OF MARINE ANIMAL IDENTIFICATION OF THE CITY OF NEW YORK (CHINATOWN DIVISION), 1992. Mixed media installation. Process view, American Fine Arts, New York (NY), USA, 1992. 02 THE LIBRARY FOR THE BIRDS OF ANTWERP, 1993. 18 African finches, tree, ceramic tiles, books, photographs, birdcages, bird traps, chemical containers, rat and snake preserved in liquid, shotgun shells, axe, nets, Audubon prints, bird nests, wax fruit, assorted objects. Installation view, "On taking a normal situation", Museum van Hedendaagse Kunst, Antwerp, Belgium, 1993. 03 POLAR BEARS AND TOUCANS (FROM AMAZONAS TO SVALBARD), 1991. Stuffed toy polar bear, Sony Sports cassette player, cassette recorded in Venezuela-Amazonas territory, wash tub, tar, crate, orange electrical cord, 231 x 112 x 75 cm.

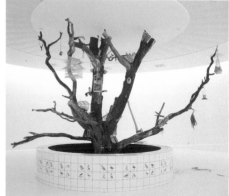

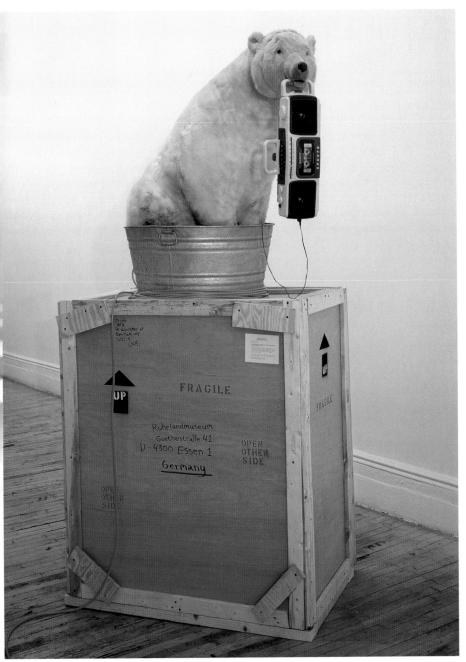

KEITH EDMIER

1967 born in Chicago (IL) / lives and works in New York (NY), USA

"The process is always some kind of support. And I want to make things that make me feel better."

The American sculptor Keith Edmier favours the narrative power of an identifiable objective realism over Minimalism or abstraction. Before becoming an artist, he worked in films as a special-effects expert, and he uses these experiences in the images and metaphors he employs, sometimes to hyper-realistic effect, sometimes with biomorphic, surreal results. He deliberately obstructs unambiguous interpretations of his sculptures, but it can be assumed that a central aspect of his work is processing traumatic childhood experiences. Edmier's "Siren" of 1995, for example, a silver stand supporting two enlarged yellow megaphones made of synthetic resin, harks back to a factory siren that plagued Edmier with its deafening noise when he was a child in Chicago. The title also recalls Odysseus's adventure with the beguiling but deadly song of the sirens. A network of allusions is the result, which mixes biographical components with historical and mythological narrative threads in a typically Postmodern style. The combination of different sources can also be traced in Edmier's sculpture "Jill Peters", 1997/98. The life-size, white wax figure no doubt represents an American high-school student, but the female figure in shorts and a rollneck pullover is also adapted from a well-known sex symbol of the 1970s. Again, diverse myths of everyday life enter into an enigmatic symbiosis. "Jill Peters" might have sprung from a bewildering daydream, but it is also charged with a touch of sublime eroticism. That too, is typical of Edmier's work. R. S.

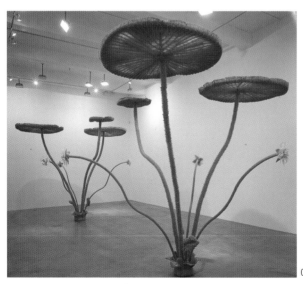

01 VICTORIA REGIA (SECOND NIGHT BLOOM) & VICTORIA REGIA (FIRST NIGHT BLOOM), 1998. Polyester resin, silicone rubber, acrylic, polyurethane, pollen, steel, 284 x 325 x 338 cm (each). **02 SUNFLOWER,** 1996. Acrylic and polymer, 333 x 107 x 66 cm. Installation view, University of South Florida Contemporary Art Museum, Tampa (FL), USA, 1997.

01 02 ▶

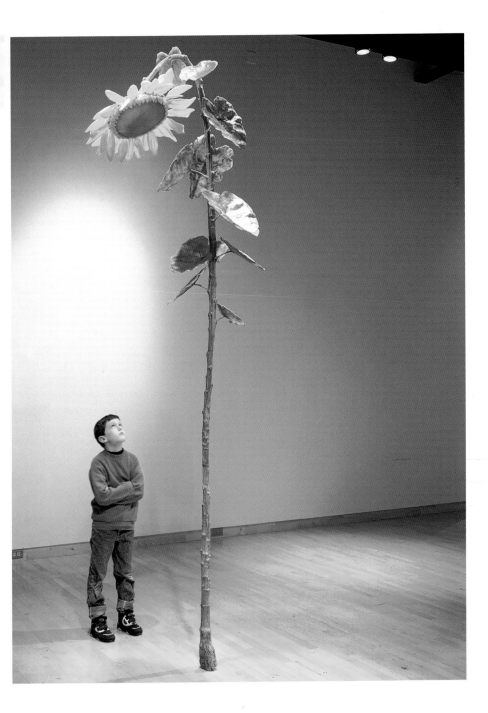

OLAFUR ELIASSON

1967 born in Copenhagen, Denmark / lives and works in Berlin, Germany

"For me a romantic idea or vision expresses a sort of belief in the worthwhileness of making art today, with a somewhat optimistic and anti-apocalyptic content."

Olafur Eliasson's "Beauty", 1993, is a perforated hosepipe emitting water and illuminated by a light. From certain angles the viewer is able to see a rainbow. In this early installation, some of the fundamental elements in Eliasson's work are already visible. Among them is his presentation or imitation of natural phenomena as art, while at the same time obviously revealing the technique used to recreate it without diminishing the impressively subtle effect. Eliasson is not primarily interested in the distinction between nature and machine but in the viewer's relationship to both. Just how fleeting the effects of his apparatuses can be, is seen in the way he projects stroboscopic light on to a water fountain, creating the impression that, for a few seconds, the water stands weightless and frozen in the air. However, he does

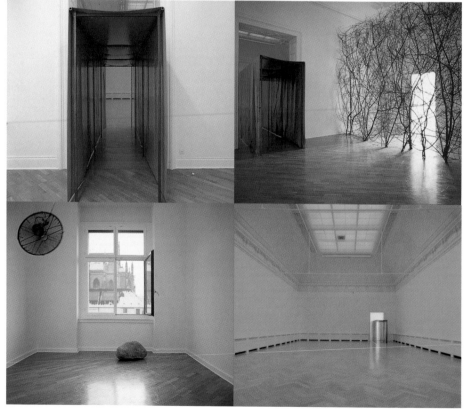

01 / 02 / 03 / 04 THE CURIOUS GARDEN. Installation views, Kunsthalle Basel, Basle, Switzerland, 1997.
05 YOUR STRANGE CERTAINTY STILL KEPT, 1996. Water, strobe lighting, sprinkler, dimensions variable. Installation view,
Tanya Bonakdar Gallery, New York (NY), USA, 1996.

not confine himself to optical phenomena. In his installation "The Curious Garden" (Kunsthalle Basel, 1997), he bathed a large, empty room in yellow light. The result was that no other colours could be perceived because of their different specific wavelengths. A narrow passage, a kind of small-scale arbour covered with a blue tarpaulin, led into a little room containing a blackthorn hedge. Cool air was supplied by an open window and a ventilator hanging from the ceiling. Again and again, using elements such as light, cold, heat, water and wind, Eliasson calls forth in the viewer an alternating range of rational reflections and spontaneous emotions. Y. D.

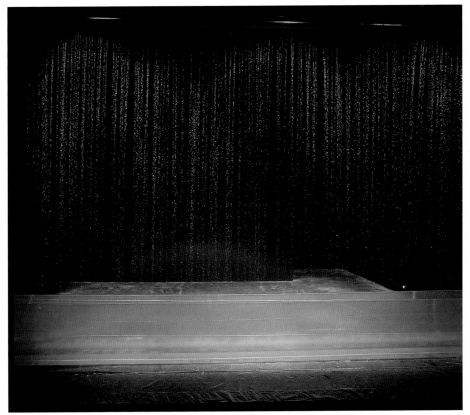

TRACEY EMIN

1963 born in London / lives and works in London, England

"I really cannot carry on living with all that stuff stuck inside of me."

"Happy as an adolescent girl – I wish." A happy youth would have been lovely, but since it wasn't like that, Tracey Emin channels the resulting fury, sadness and bruised ego into her works. The facts of her life story are presented with a sharp directness – whether the loss of her virginity at the age of 13 through rape ("Exploration of the Soul", 1993), or the names of all the people she has ever shared a bed with ("Everyone I Have Ever Slept With 1963–1995", 1995). Symbols of salvaged passionate and painful experiences, the names were embroidered on the inside of a tent, which represented both shelter and restlessness. Her memories provide her material, the form dictated by her living them down. She has sewn names, words, whole texts on fabrics or cushions in a manic gesture of inner integration. These pieces and her videos, her journeys of remembrance to the scenes of her youth, bring to light a long-forgotten function of art that emerges so abruptly that it upsets. It is, as Emin herself has often empha-sised, spiritual. "Exorcism of the Last Painting I Ever Made", 1997/98, was a gallery presentation of

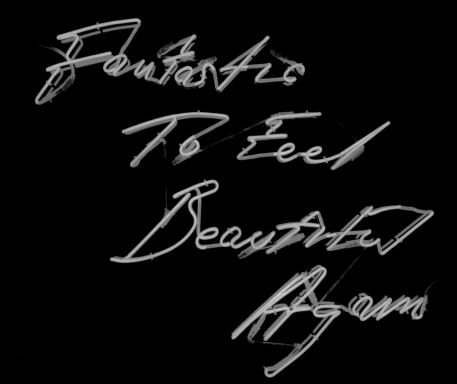

her studio: sketches, paintings, texts, everyday odds and ends, photos, souvenirs, a cassette recorder, books, a bed and underwear on clothes lines. During the opening she sat on the bed, conducting on video an ecstatic painting performance, an exorcism with paint and the naked body. Emin's exhibitionism is less embarrassing than it is stimulating and constructive. Memorable and intense, her work poses the question of the meaning of art today. S. T.

◄ 01 / 02

01 FANTASTIC TO FEEL BEAUTIFUL AGAIN, 1997. Neon, 107 x 127 x 10 cm.
02 EVERYONE I HAVE EVER SLEPT WITH 1963–1995, 1995. Appliquéd tent, mattress and light, 122 x 245 x 215 cm.

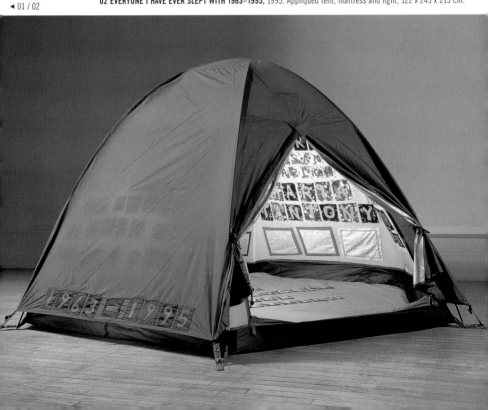

SYLVIE FLEURY

1961 born in Geneva / lives and works in Geneva, Switzerland

"I show things as they are. In this way I also exhibit the instruments and mechanisms that make them what they are."

Sylvie Fleury is super-elegant in appearance. She is always expensively well-dressed, radiating a luxury that is like something from the advertising world come to life. Just as naturally, she presents the attributes of luxury as works of art. She exhibits collections of ladies' shoes, the carrier bags of exclusive boutiques, works in neon lettering with advertising slogans for wickedly expensive skin creams, or builds huge rockets to Venus covered with shaggy fur. Both her appearance and her works give the impression that she is quite unable to distance herself from the glittering world of consumerism. She thwarts the general expectation that artists should, on principle, behave critically towards our commercial consumer society. Sooner or later this raises the question of whether she is really so naive or whether perhaps there is more to this work than meets the eye. And this is the point at which her subtle provocation comes into play. By transferring desirable accessories such as Chanel perfumes into the context of art, she gives the impression that she places them on the same level as art itself. In art, as in cosmetics,

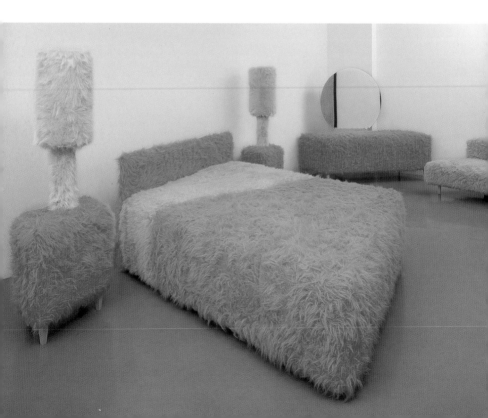

01 BEDROOM ENSEMBLE, 1997. Artifical fell, wood construction. Installation view, Galerie Mehdi Chouakri, Berlin, Germany, 1997.
02 SKIN CRIME NO. 303, 1997 (foreground); **SKIN CRIME NO. 601,** 1997 (background). Car, car painting, c. 390 x 190 x 50 cm (each).
Installation view, Galerie Bob van Orsouw, Zurich, Switzerland, 1997.

there are considerable differences in quality, and the awareness of this is steered by marketing initiatives.
The art market is small in comparison with that for luxury goods, but the criteria that determine success
or failure suddenly seem very similar in the light of Fleury's world. C. B.

◄ 01 / 02

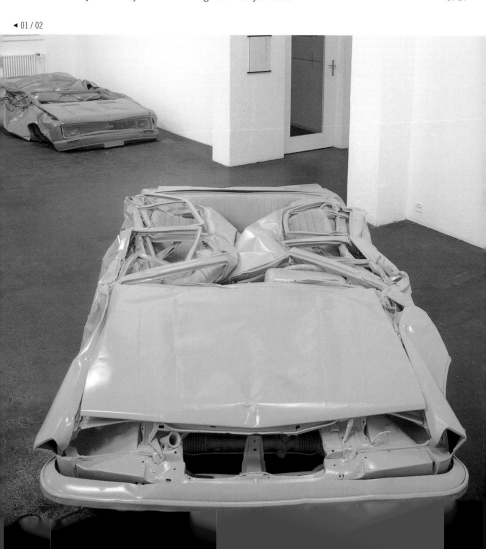

GÜNTHER FÖRG

1952 born in Füssen, Germany / lives and works in Areuse, Switzerland

"What I like doing is reacting to things."

The painter, photographer and sculptor Günther Förg sprints through the ideas of Modernism in art at a fair lick, while at the same time giving them a workover. Piet Mondrian, the Bauhaus and the Russian avant-garde at the beginning of the last century, but also more contemporary figures such as Barnett Newman, Jean Fautrier and the legendary film-maker Jean-Luc Godard, are as it were the "ancestors" of his art, which often takes the form of closely related installations. This artistic strategy of conscious quotation from the past became apparent in one of his first important museum exhibitions, at the Museum Haus Lange in Krefeld in 1987. Monochrome wall paintings, echoing in their coloring the Wittgenstein House in Vienna, were translated by Förg on to the architecture of Mies van der Rohe. Lively debate ensued concerning the two architectural concepts. Likewise in painting, e. g. his numerous grid paintings of the 1990s reminiscent of the New York works of Mondrian's late period, Förg quotes examples from the classic moderns. He ridicules their unbroken authority in a colloquial, rapid, almost slipshod translation. This critical approach is accentuated in many of Förg's photographic works. An example is the "Architektur Moskau 1923–1941" (Moscow Architecture) series of 1995. Here, he photographed Moscow's badly deteriorating avant-garde architecture as though he were a dispassionate passer-by. Cutting is almost left to chance, and the contours are sometimes fuzzy, but these thirty photos tell of the failure of a utopia. Typically for Förg, they also possess a memorable beauty. In their casual gestural treatment of surfaces, Förg's – usually bronze – sculptures bear witness to a state of transience, which has given rise to his reputation as "a stroller through Modernism". R. S.

01 UNTITLED (BLEIBILD), 1986. Acrylic, lead sheet, wood, 3 panels, 120 x 90 x 4 cm (each).
02 WANDMALEREI, 1991. Permanent installation, Museum für Moderne Kunst, Frankfurt/M., Germany.

01

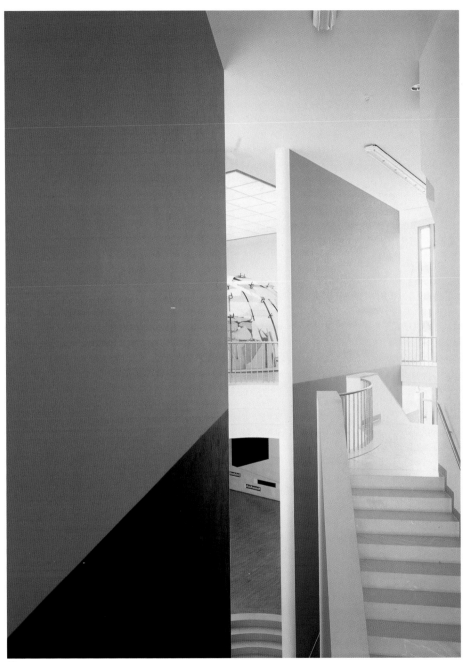

KATHARINA FRITSCH

1956 born in Essen / lives and works in Düsseldorf, Germany

"Anyone should be the audience. Anyone should be able to look at my images
and I think that anyone can understand them as well."

Throughout the 20th century, many ordinary objects were called art. Although at first sight Katharina Fritsch may appear to be part of this tradition, in fact she takes an entirely different approach. Her objects – the "Vases" (1979, 1984, 1987), the "Candlesticks", 1985, the green "Elephant", 1987, the yellow "Madonna", 1987, the huge "Company at Table", 1988, and the even larger "Rat King", 1993, are all specially crafted objects. Every detail, from the smallest edge to the precise colour tone, is subjected to her artistic scrutiny until the ideal state is finally reached. This lavish production process meant that during the 1980s, she produced very few works, creating great anticipation within the art world. Fritsch's works are poised on a knife-edge between the unique and the arbitrary. Because she controls their sculptural appearance so minutely, reducing them to the minimal forms necessary for recognition without deviating for a moment into the abstract, they become one-offs that allow no other option. No aspect of her work is allowed to give rise to discussion as to whether a different solution would have been possible. In "Tischgesellschaft" (Company at Table), Fritsch extended what she had begun with objects into communication situations, transferring this principle into the realm of fairy-tale illustration with the sculpture "Rattenkönig" (Rat King), a group of rodents with knotted tails. Since the perfection of her works was often in stark contrast to the space in which they were exhibited, she eventually designed an ideal museum for the German pavilion at the Venice Biennale of 1995. C. B.

01 RATTENKÖNIG (RAT KING). Installation view, Dia Center for the Arts, New York (NY), USA, 1993/94. **02 TISCHGESELLSCHAFT (COMPANY AT TABLE),** 1988. Polyester, wood, cotton, paint, 1.4 x 16 x 1.75 m.

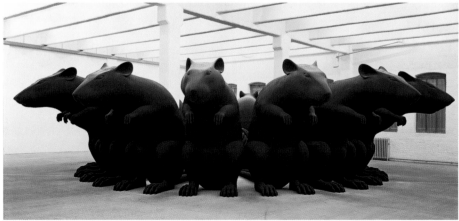

01

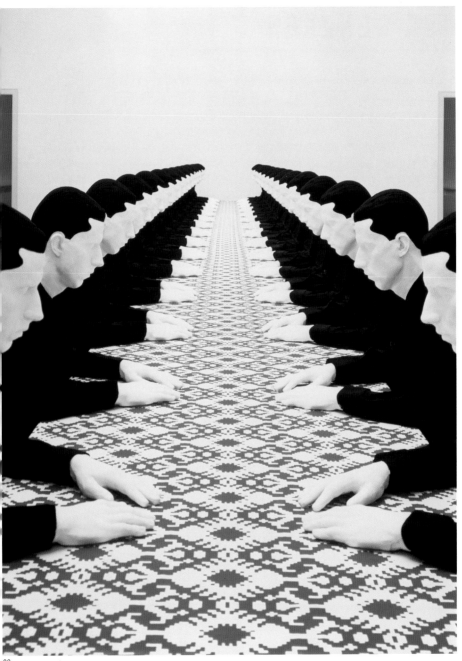

ISA GENZKEN

1948 born in Bad Oldesloe, Germany / lives and works in Berlin, Germany

"... a sculpture, even when it displays architectural elements, remains a sculpture."

Isa Genzken's work moves between two poles: the claim to artistic autonomy, and reference to the personal, social and institutional. Following on from Russian Constructivism, through Minimal Art and Concept Art, Genzken's sculptures are conditioned by their interrelationship with their surroundings. Thus, she opens up her "Ellipsoiden", 1976–1982, and "Hyperbolos", 1979–1983 – stereometric structures in lacquered wood – by making an incision in their closed form. Similarly, her plaster sculptures, 1985/86, concrete pieces on steel-tube scaffolding (from 1986), and her outside works thematically illustrate the transition between interior and exterior. Many of these works including "ABC", 1987, quote architectural models. The viewer recognises details of the town as if seen through a frame or, as in "Fenster" (Window), 1990, details of the gallery. The choice of materials is of central importance. From 1991, she often used concrete, the typical building material of Modernism, and later, materials such as translucent epoxy resin, which leaves the supporting construction visible. Sculpture also informs works like the X-rays of her head ("X-Ray", 1991), her photographs of human ears ("Ohren" (Ears), 1980), or "Weltempfänger" (Global Receiver), 1982–1987, which function as metaphors for exchange and communication. In 1994, Genzken varied these subjects with subtle irony: the arrangement of two revolving columns, the lamp-like "Haube I (Frau)" and "Haube II (Mann)", and a replica of the gallery window indicate both self-reference and outside orientation. Her stelae of 1998 combine personal references with the abstract language of forms: she fitted photographs of a stay in New York and of her Berlin studio into a screen of pressboard, marble, mirror and metal.

A. W.

01 METLIFE, 1996. Installation view, Generali Foundation, Vienna, Austria, 1996.
02 ROSE, 1997. Stainless steel, lacquer, 8 m (h). Permanent sculpture, Messe Leipzig, Leipzig, Germany.

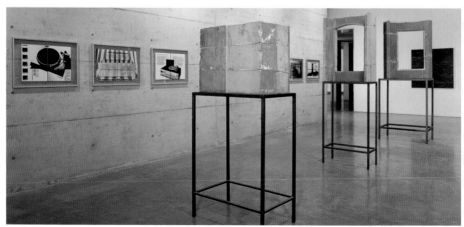

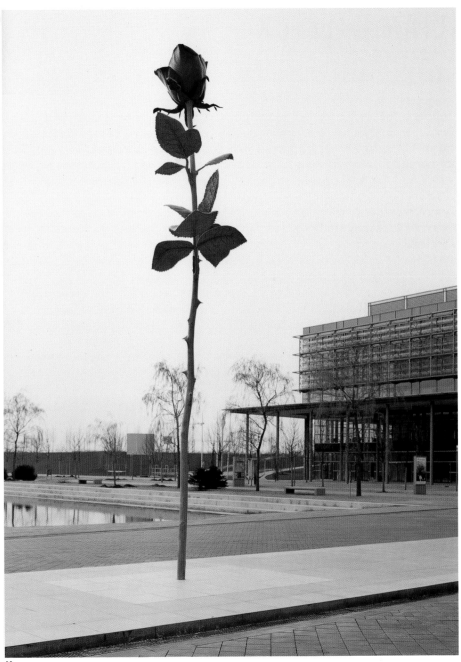

LIAM GILLICK

1964 born in Aylesbury, England / lives and works in London, England, and New York (NY), USA
"I want to reclaim an area of fluidity, that might include elements of the poetic,
the informational and pure aesthetics but all of this is framed by a constant play between
activity and analysis."

Liam Gillick is one of the most fascinating artists of the last ten years, and at the same time one of
the most difficult to understand. His works seem unfinished, both in terms of presentation and of content.
The objects, films, screenplays and dramas often relate to one another, which means that the viewer ei-
ther needs a good deal of knowledge, or should be prepared to think hard. But this excessive requirement
is offset by the fact that it constitutes an important component of the work. Gillick presents the diversity
of this world as the gulf between reality and utopia. In time-leaps shifting between 1810 and 1997, he
moves from McNamara, the American Minister of Defence at the time of the Vietnam War, to Erasmus
Darwin, the 18th-century physician and radical thinker, whom he brings on stage in a musical. He pre-
sents coloured wall screens that look like designer furniture but bear the label "Discussion Island Develop-
ment Screen". The themes and information he delivers are therefore partly real and partly fictitious. Solu-
tions and final conclusions are never on offer. In this way, Gillick reflects the fact that all decisions are
made subjectively, according to what is known and of interest at that moment. Their expiry date immedi-
ately ensues, and every re-assessment on the basis of new information, whether this is correct or not,
can lead to different decisions, which will prove to be more or less sensible. Gillick's works function in

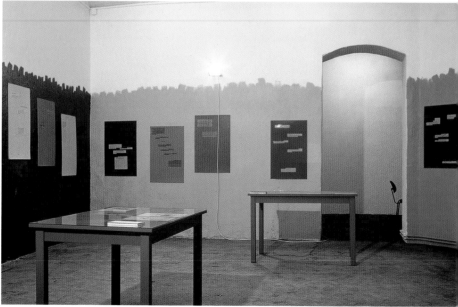

1 **ERASMUS IS LATE IN BERLIN DRAWING TABLES,** 1996 (foreground). 2 blue/grey tables, laser prints on coloured paper, glass, copies of "Erasmus is Late", variable. **ERASMUS IS LATE IN BERLIN INFORMATION ROOM,** 1996 (background). Clay brown, lime green and light blue walls, halogen spotlights, 12 card boards with collaged information, 4 sheets of text in German, variable. Installation view, "Erasmus is Late in Berlin versus' The What If? Scenario", Schipper & Krome, Berlin, Germany, 1996. **02 DISCUSSION ISLAND RESIGNATION PLATFORM,** 1997. Aluminium angle, plexiglas, fittings, 360 x 240 cm.

precisely the same way: they are never complete, always undergoing a process of alteration. Their valid-
ity is of short duration, but in this brief time, they hit the viewers' feelings exactly. C. B.

NAN GOLDIN

1953 born in Washington, D. C. / lives and works in New York (NY), USA

"My work derives from the snapshot. It is the form of photography that most closely stands for love."

Nan Goldin must have been the most popular female photographer of the 1990s. In the last thirty years she has created a kind of "visual diary". In this the American artist sensitively records her world, above all her friends, lovers, male and female, her trips to Europe and Asia and her crises – often in relationships. Goldin thus created an intimate panorama of the human condition towards the end of the 20th century, not only with her photographs but also in her slide shows backed up with music, like "The Ballad of Sexual Dependency", 1981–1996, or her film "I'll Be Your Mirror", 1995. She has repeatedly directed her attention at areas of life in which people's relations to love, sexuality and the division of roles between the sexes are as intense as they are open – lesbian and gay culture as well as the seemingly glamorous world of the transvestites. This is her own world and so she shoots her photos without any voyeuristic indiscretion. Nan Goldin often works in series. She has been photographing many of her "protagonists" over a period of more than twenty years. In order to do justice to the complexity of the human condition between longing and failure, she puts her trust in "the accumulation of portraits as the representation of a person" (Goldin). The "Portfolio Cookie Mueller", 1976, is an important example. In 17 pictures Goldin traces her relationship with this star of several John Waters films, from their early encounters up to the burial of her friend when she died of AIDS. Even the most intimate is here made

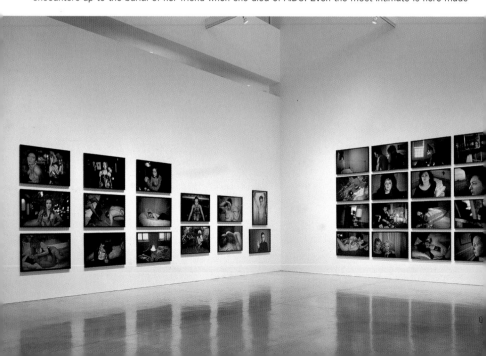

public, and the boundaries of shame or social taboos are not accepted. Nan Goldin realises that it is pre-
cisely those that take new soundings in the patterns of human togetherness who are threatened by social
disciplining and supervision. What remains is escaping to the fore, into the floodlight of publicity. R. S.

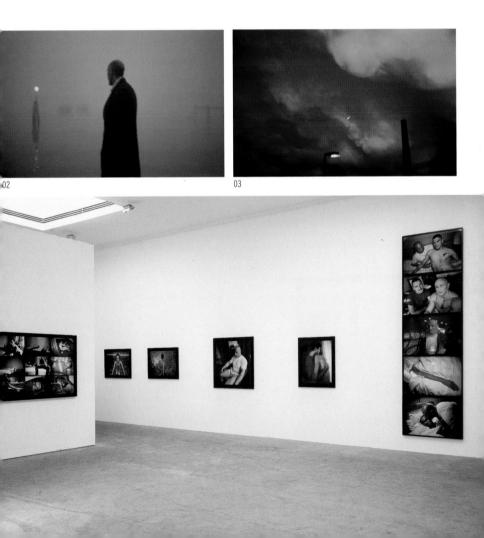

02

03

FELIX GONZALEZ-TORRES

1957 born in Güaimaro, Cuba / lived and worked in New York (NY) / 1996 died in Miami (FL), USA

"I tend to think of myself as a theater director who is trying to convey some ideas by reinterpreting the notion of the division of roles: author, public and director."

Felix Gonzalez-Torres subtly combined personal experiences and ideas from art theory with political points of view. He often reflects aspects of his particular position as a gay artist from Cuba, but without falling into banal clichés. His installations of piles of paper and sweets indicate a direct connection with the Conceptual and Minimal Art of the 1960s. But by inviting gallery visitors to help themselves to a sheet of paper or a sweet, these works negate the claim to artistic autonomy that is characteristic of Minimal Art by questioning the uniqueness of the artwork. Everyday things like light bulbs or sweets wrapped in cellophane are invested, simply through their selection and arrangement, with a poetic aura. This is also present now and then in his atmospherically charged reproductions of his posters and puzzles. Ambiguous images, like footprints in sand dunes or two birds flying past in the cloudy sky, sharpen our awareness of transience or the fear of losing a loved one – a fundamental theme not only in the age of AIDS. The intimate image of a recently slept-in bed, which Gonzalez-Torres stuck on various billboards in New York shortly after the death of his partner, expressed his personal mourning, but like many of his works, also transferred the private emotion into the public arena, making us aware of the general relevance of such themes as illness, death, love and loss. Y. D.

01 UNTITLED (AMERICA), 1994/95. 15 watt light bulbs, rubber light sockets, extension cords, dimensions variable; 12 parts, 18.8 m in length (each) with 7.4 m of extra cord (each). Installation view, Limerick City, Ireland, 1996. **02 UNTITLED,** 1991. Billboard, dimensions variable. Installation view, "Projects 34: Felix Gonzalez-Torres", The Museum of Modern Art, New York (NY), USA, 1992. **03 UNTITLED (ROSS),** 1991. Candies wrapped in variously coloured cellophane, unlimited supply, ideal weight: 175 lbs, dimensions variable. Installed at the home of Karen & Andy Stillpass. **04 UNTITLED (FOR STOCKHOLM),** 1992 (foreground). 15 watt light bulbs, porcelain light sockets, extension cords, dimensions variable; 12 parts, 18.6 m in length (each) with 6.1 m of extra cord (each). **UNTITLED,** 1989–1995 (background). Paint on wall, dimensions variable. Installation view, Kunstmuseum St. Gallen, St. Gallen, Switzerland, 1997.

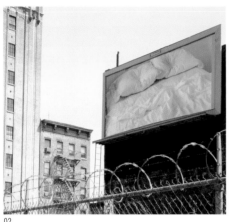

02

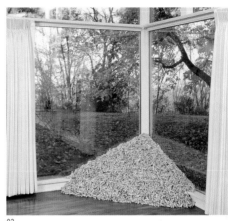

03

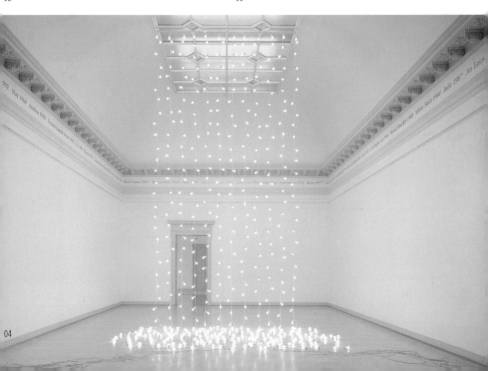

04

DOUGLAS GORDON

1966 born in Glasgow / lives and works in Glasgow, Scotland, and Cologne, Germany

"The artist as a captor can be quite content to sit in the background, and if everything is running smoothly, he can play an anonymous role in the equation."

Douglas Gordon's video work makes impact through its slow pace. Time and again a finger crooks in slow motion as though pulling the trigger of a revolver; time and again a man falls down headlong, or two psychiatrists endlessly try to calm a patient. Gordon often uses snippets from medical films dating from the turn of the last century. At that time, film's value as a medium of entertainment had not yet been realised – it was seen rather as a means of scientific documentation. With these works Gordon counteracts the rapid sequence of images in contemporary clips. Every second seems to take on a new meaning through the dragging-out of time, as though things that had been forgotten could be rediscovered in slow motion. When he presents Alfred Hitchcock's film "Psycho" slowed down to run for over 24 hours, the initial effect is that the viewer takes scenes in very gradually. After a while, one remembers one has seen these or similar images before. Gordon employs memorable material, distracting the viewer with its slowness, deflecting one on to other thoughts – where and when did I see these pictures? Who with? Can I bend my finger like that too? A similar idea of personal memory is used in a series of large written works that simply consist of the names of everyone Douglas has ever met. From 1,440 people in the first presentation of 1990, the "List of Names" grew to 2,756 in 1996. Like the life of Gordon himself, it is an ongoing project, made in slow motion. C. B.

01 TWENTY FOUR HOUR PSYCHO, 1993 (detail). Video installation, 24 hour video. **02 TWENTY FOUR HOUR PSYCHO,** 1993. Video installation, Tramway, Glasgow, Scotland, 1993. **03 A DIVIDED SELF II,** 1996. Video installation, dimensions variable. Installation view, "The Turner Prize 1996", Tate Gallery, London, England, 1996/97. **04 REMOTE VIEWING 13.05.94 (HORROR MOVIE),** 1995. Wall painted Pantone 485A; screen size, 400 x 300 cm. Video installation, "Wild Walls", Stedelijk Museum, Amsterdam, The Netherlands, 1995.

ANDREAS GURSKY

1955 born in Leipzig, Germany / lives and works in Düsseldorf, Germany

"There is obviously a common language of the unconscious that everyone can understand ..."

Andreas Gursky's colour photographs of townscapes and landscapes, assemblies of people, factory floors, motorways and sports facilities combine the documentary approach of the school of Bernd and Hilla Becher with a positively painterly use of colour. His panoramas are photographed from an elevated viewpoint, capturing situations of daily life and recording even the smallest detail. Works made between 1984 and 1988 show people at leisure, normally in urban neighbourhood recreation grounds. Gursky was exploring the relationship between people and the organisational structures of their environment, a theme that would be central in his later large-scale tableaux. The individual in Gursky's picture compositions recedes into the background, recognisable, as in "Angler, Mülheim", 1989, only as a tiny figure. In "Börse, Tokyo" (Stock Exchange, Tokyo), 1990, and in "May Day", 1997, he is submerged in the mass of brokers or concert-goers. In other works, the individual virtually disappears behind anonymous architecture or the production sites of industrial places. The frontal, latticed structure in "Paris, Montparnasse", 1993, recalls not only the serial sequences of Minimal Art or Gerhard Richter's coloured paintings, but also picks up on the even spread of Jackson Pollock's all-over canvases. Gursky emphasises this aspect in his picture "Ohne Titel" (Untitled), 1993. The oscillation between the concreteness of his subjects and the aesthetic composition of these "remembered pictures", as Gursky once put it, is characteristic of his work. His is a kind of photographic stock-taking distilled into symbols of Western civilisation. A. W.

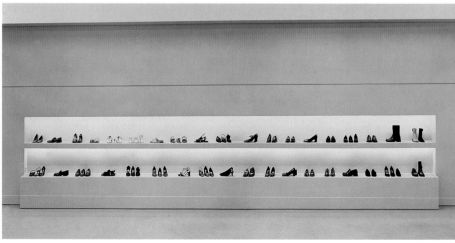

01 PRADA I, 1996. Mixed media, 135 x 226 cm.
02 HONG KONG, GRAND HYATT PARK, 1994. Mixed media, 210 x 175 cm.

PETER HALLEY

1953 born in New York / lives and works in New York (NY), USA

"A painting cannot be topical or about transitory aspects of the social.
It's got to be about the absolute essential."

As a student, Peter Halley encountered Guy Debord's Situation Theory, the Structuralism of Lacan, Lévi-Strauss, Barthes and Foucault and Post-structuralism of Baudrillard and Derrida. From 1984 to 198? he was a member of the gallery International with Monument, which, founded by Ashley Bickerton, Jeff Koons and Meyer Vaisman and Halley himself, gave rise to the Neo Geo movement. Characterised by Day-Glo fluorescent colours and a synthetic Roll-a-Tex surface rendering, Halley's large geometrical compositions are parodies, Postmodern, "simulationist" critiques of Mondrian, Albers, Stella and Judd. He uses his art to challenge both capitalism and the anti-capitalist revolutionary utopias of the 1970s, attempting to strip away the mythology of both the "capitalists" of abstraction and the Conceptualists, and to repudiate division of labour and class distinctions in any form. Halley had no alternative but to counter the compromises inherent in his art with the leftist concept of an "alternative culture" reflecting his ideals. "Whereas Smithson imposed the symbols of an ideal geometry on the ravaged industrial landscape, I on the contrary should like to help the ideal world of geometrical art to find the trail of a social landscape," he wrote as early as 1981. With his schematic geometry – computer printouts, impressions of computer circuits, drawings of cell structures, plans of motorways or airport runaways – Halley aims to show that the art of abstraction by no means represents a purely self-referential style but clarifies the significance of mathematical modelling, which has established itself in all areas of science since the beginning of the 20th century. J.-M. R.

01 (((0))), 1993. Acrylic, Day-Glo acrylic, Roll-a-Tex on canvas, 238 x 230 cm. **02 POWDER**, 1995. Acrylic, Day-Glo acrylic, Roll-a-Tex on canvas, 234 x 318 cm. **03 OVERTIME**, 1997. Day-Glo and metall acrylic, acrylic, Roll-a-Tex on canvas, 236 x 183 cm.

01

0

GEORG HEROLD

1947 born in Jena, Germany / lives and works in Cologne, Germany

"Some like it Quark. Some like it canvas."

In producing his pictures, sculptures and installations, Georg Herold consciously renounces elaborate or perfectionist techniques and traditional materials in favour of an assemblage of heterogenous materials such as roof battens, bricks, caviar and wire that are foreign to every established artistic tradition. The themes he tackles range from art history ("Dürerhase", 1984), to society ("No-No/No AIDS – No Heroes", 1990) and politics ("RAF", 1990). His specific concern with language is not only clear from his choice of provocative titles, but is also evident in an on-going, constantly updated glossary that he has been working on for almost twenty years and which regularly appears in his catalogues in a continually enlarged and updated version. In many of his works, Herold refers in multifarious ways to the works of other artists. A house made of neon tubes, for instance, captioned "Cyber-Merz", 1995, alludes according to Herold to the German artist Gerhard Merz, the Italian Mario Merz and the Merz constructions of

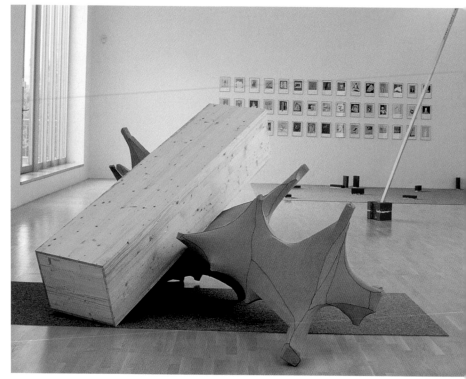

01 SKULPTUR VOM SOCKEL ERSCHLAGEN, 1992. Slats, thread, wood, canvas, 370 x 120 x 175 cm; plinth, 240 x 55 x 45 cm. Installation view, "Miserere", Kunsthalle Ritter Klagenfurt, Klagenfurt, Austria, 1993 (with Werner Büttner).
02 GELANDETE HORIZONTE, 1996. Distilled water, glass, wood; plinth, 164 x 270 x 39 cm.

Kurt Schwitters. With these references, Herold is not only positioning his own work within art history, but is also ironically questioning our attitude to stylistic features in the marketing system of the art world. He often assimilates scientific discoveries, current political headlines and social and cultural aspects into his pieces, working them up in a Dadaistic style. Brought up in the former German Democratic Republic and emigrating to the West in 1973, Herold also frequently comments on German history in his art. Y. D.

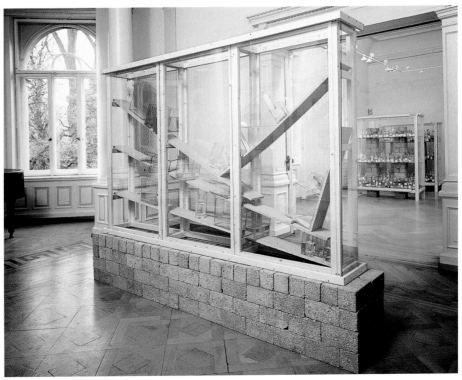

GARY HILL

1951 born in Santa Monica (CA) / lives and works in Seattle (WA), USA

"And for everything which is visible there is a copy of that which is hidden."

More than any other artist, Gary Hill succeeds in using modern technology to create the aura of physical presence. Many of his video artworks present people who seem so real you have the feeling they're actually in the room with you. In "Tall Ships", 1992, the figures projected on the walls of a long room through which the viewer walks seem to react to one's presence personally, advancing as one approaches and turning away when one moves off again. Contact with the line of slightly larger-than-life workers in "Viewer", 1996 is more direct and thus more eerie. Seventeen men of different races stand silently in front of you, moving a little from time to time. You feel they could start marching at any moment. When Hill presents a little girl reading from Wittgenstein's "Bemerkungen über die Farbe" (Observations on Colour) in 1994, or, in "Circular Breathing" of the same year, projects five images in a breathing rhythm that goes from rapid to slow, he evokes the sensation of direct physical experience. One's reception of the work seems to take place simultaneously with what's happening: you tremble for the little girl with each sentence, for she can read the text but clearly cannot understand it. Similarly, in

01 INCIDENCE OF CATASTROPHE, 1987/88. Videotape, colour, stereo sound, 43:51 mins. **02 VIEWER,** 1996 (detail). 5-channel video installation, 5 laserdisc players, 5 projectors, 5-channel synchronizer. **03 I BELIEVE IT IS AN IMAGE IN LIGHT OF THE OTHER,** 1991/92 (detail). Mixed media installation, 7-channel video, modified TV tubes for projection, books, speaker.

the picture sequences you are tempted to adapt your breathing to the rhythm of the film. Hill recounts momentary scenes, meetings between human beings, which make you almost forget that the others do not actually exist.

C. B.

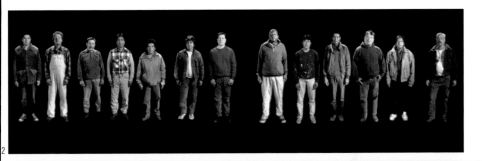

CANDIDA HÖFER

1944 in Eberswalde, Germany / lives and works in Cologne, Germany

"I am looking for the similar in public spaces, though what attracts me is the differences between these similarities."

A former pupil of Bernd Becher, Candida Höfer became known for her colour photographs of public or semi-public interiors. Since 1979 she has devoted herself to this theme, supplemented from 1990 onwards by her "Zoologische Gärten" (Zoos). In this, she has followed an unchanging artistic concept: she works with a small camera, usually without a tripod, a light wide-angle lens and available light only. The photos are generally presented in a 38 x 38 cm or 38 x 57 cm format. Despite this repetitive working principle, Höfer's pictures do not conform to the serial nature of Becher's industrial typologies, for the position of the camera, and thus the composition of the picture, are determined by the individual character of the room. She avoids a centralising composition, preferring to let her gaze flit over apparently incidental places. Her locations – waiting rooms, hotel lobbies, university lecture rooms, libraries, museums – are public places in which people are exposed to each other's scrutiny, rather like zoo animals in their enclosures. They are places of transit, but also of retention. Different levels of time come together in her works: the history of the architecture, the present function of the location and the time when the photograph was shot. There is often evidence of the present use of the rooms, which are usually devoid of people, but this doesn't detract from their multifunctional arrangement. An unorthodox conception of history emerges. This is not cut and dried, but shifts with the perspective selected. Höfer's

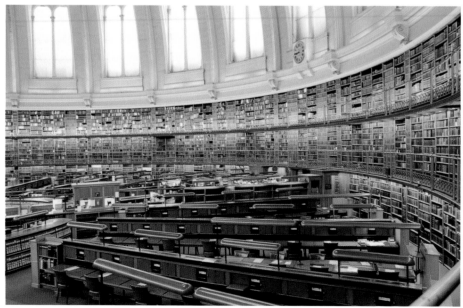

compositional openness is therefore more than a principle of style: she opposes the desire for order and control that is often visible in architecture and the organisation of interiors. A. W.

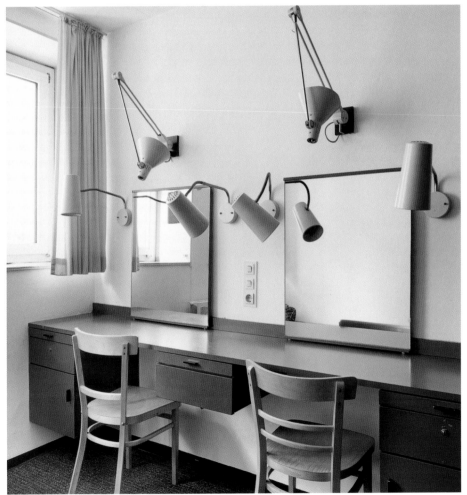

CARSTEN HÖLLER

1961 born in Brussels, Belgium / lives and works in Cologne, Germany
"What I was very fond of – even at school – is the new maths, because it is a
pre-mathematical process which operates visually and can illustrate connections by means
of simple methods."

Carsten Höller has been working as an artist since the beginning of the 1990s, but also has a doctorate in agricultural science and is a specialist in insect behaviour. This confluence of art and science gives his works their particular character. In form, they often remind us of laboratory structures in which the viewer becomes the object of the experiment. His works make it possible to fly round in a circle, immerse one's head in an aquarium, be propelled across the water or speed down a slope in a sound-proofed sledge. In 1997 at documenta X in Kassel, he produced, along with Rosemarie Trockel, the "Haus für Schweine und Menschen" (House for Pigs and People), which revealed not only the life of a pedigree breed of pig but also the behaviour of humans. The two were separated by a glass plate, and each was allotted a pleasant and appropriate environment. The pigs had an excellent sty with access to an enclosure outside, and the human beings a platform with soft mats on which they could devote themselves to relaxed observation. Yet, these worlds of experience staged by Höller do not exist in isolation, but are extended through lectures, symposia and books with theoretical texts. Scientists and philosophers ponder on the processes to which the works give rise. The objects are therefore consciously aimed at provoking confrontations that extend far beyond art alone.

C. B.

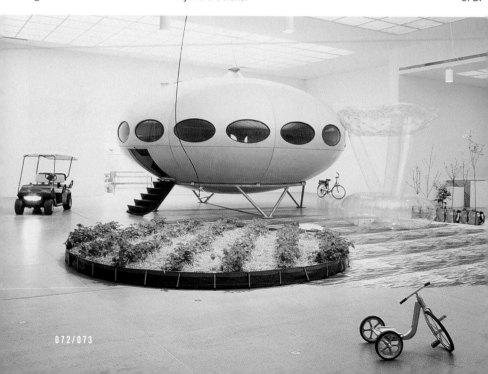

01 "SKOP", installation view, Wiener Secession, Vienna, Austria, 1996. **02 KINDERFALLE (FROM THE SERIES "KILLING CHILDREN III"),** 1994. Plugs, flex and chocolates. Installation view, Ynglingagatan 1, Stockholm, Sweden, 1994. **03 HARD, HARD TO BE A BABY,** 1992. Child's swing. Installation view, "UFO Project", Air de Paris, Nice, France, 1992. **04 EIN HAUS FÜR SCHWEINE UND MENSCHEN,** 1997. Installation view, documenta X, Kassel, Germany, 1997 (in collaboration with Rosemarie Trockel).

02

03

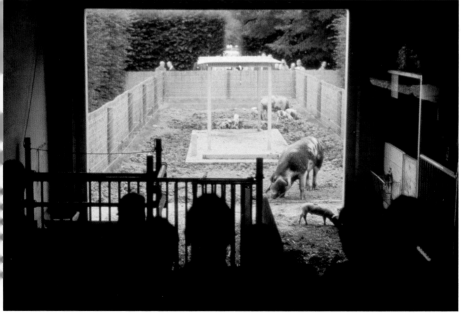

JENNY HOLZER

1950 born in Gallipolis (OH) / lives and works in Hoosick (NY), USA

"I am happy when my material is mixed with advertisements or pronouncements of some sort or another."

Jenny Holzer's works use the structures of the mass media and aesthetics of the current milieu to smuggle messages into the public arena. As these are often directed at the casual viewer, simplicity and media support are important criteria. Holzer's pointed one-liners, which have become her signature, crop up on posters, T-shirts and illuminated advertising boards. Her "Truisms", 1977–1979, were fly-posted anonymously in the streets of Manhattan, and in 1982 were flashed up on an illuminated advertising board in Times Square. She has also displayed, like information notices in public places, metal plates engraved with aphorisms from the "Living" series, 1980–1982. What is provocative about Holzer's work is not just her subject matter – which, as she declared at the Venice Biennale of 1990, always revolves around "sex, death and war" – but her refusal to take up a clear position, an ambiguity that is often associated with the feminist demand for multiple identities. This semantic indeterminacy also marks Holzer's project "Lustmord" (Sex Murder), conceived in 1993 as a newspaper supplement. The experience of sexual violence and death is depicted from the perspective of the culprit, the victim and the witness, in brief, sometimes aggressive sentences. Subsequently Holzer has shown this work in various different versions, as a 3D-LED installation in Bergen (1994), as illuminated words at the Battle of Leipzig monument in that city (1996), or as a quasi-religious display in the art museum of the Swiss canton of Thurgau (1996). For the latter, she meticulously lined up bones bearing texts on metal strips – a reference to the human urge, both hopeless and macabre, to supervise death. In her wish to touch the viewer's emotions Holzer bravely walks a tightrope between dramatic directness, seductive superficiality and the need for distanced reconsideration. A. W.

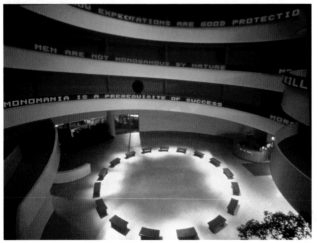

01 INSTALLATION VIEW. LED sign, red granite benches. Solomon R. Guggenheim Museum, New York (NY), USA, 1989/90.
02 KRIEGSZUSTAND, Leipzig Monument Project. (Völkerschlachtdenkmal). Laser projection. Outdoor installation, Galerie für zeitgenössische Kunst Leipzig, Leipzig, Germany, 1996.

01

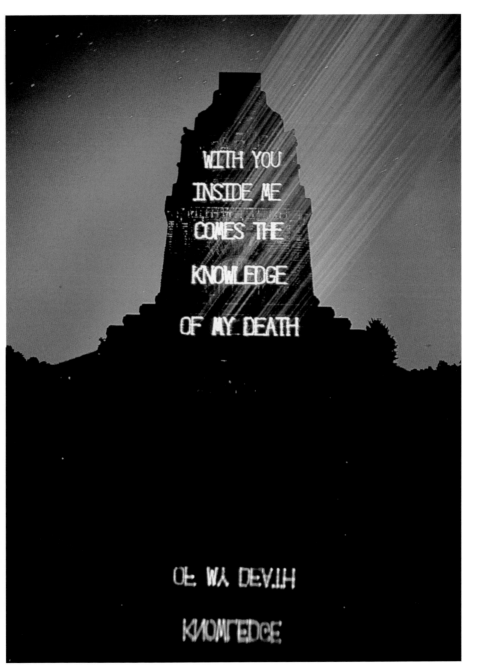

RONI HORN

1955 born in New York / lives and works in New York (NY), USA

"An object is capable of creating the place in which it is shown."

Since 1976 Roni Horn has been attempting, in a kind of Minimalist act of conquest, to seize the immeasurable by means of fragility and a radical simplicity. It is principally her choice of material that gives her work its clear, direct elegance, and she bases her sculptures on the specific physical and psychological qualities of that material. To use the artist's own phrase, the sculptures form a "store of experiences", and are ultimately aimed at confirming the particular nature of the substances she uses. In multifarious combinations, Horn brings out the polarities from which her materials take their definition. The power and strength of steel finds its counterpart in the weight and malleability of lead, the suppleness of rubber or the lightness and fragility of balsa wood. Her sculptures are always placed on the floor, in order to emphasise the different relationships that the various materials seem to have with gravity. Balsa "hovers", lead "flows", gold reflects the rays of light, while coal dust absorbs the light. The artist's photographic work, mainly executed in Iceland, is concerned with the qualities of space. The relationship between place and perception is explored in "Tourists At Gullfoss, Iceland", 1994, while in her photo series "You are the Weather", 1994–1996, Horn concentrates entirely on the moment of perception. A young woman by the water is photographed in an extensive sequence of near-identical images, so that every nuance, each freckle and little hair takes on significance. "The water conveys her image," the artist writes, thus emphasising the interaction of space and perception. J.-M. R.

01 STEVEN'S BOUQUET, 1991. Plastic, aluminium, 6 parts, 107 x 127 x 38 cm (total).
Installation view, Jablonka Galerie, Cologne, Germany, 1992. **02 YOU ARE THE WEATHER,** 1994–1996 (details).
Series of 100 photographs (36 b/w and 64 colour photographs), 27 x 21 cm (each).

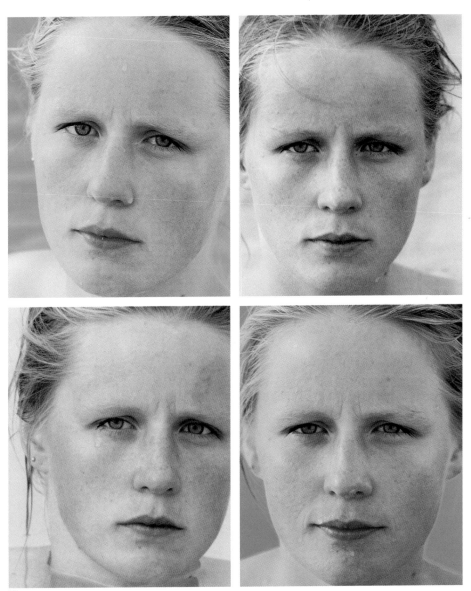

GARY HUME

1962 born in Kent, England / lives and works in London, England

"I can bear looking at the paintings for days on end, living with them. Beautiful, sensuous and intelligent, hard, deep, soft. That sounded just like sex, didn't it?"

Gary Hume prefers items from everyday life and popular culture both as the subjects of his pictures and as his materials. He uses ordinary commercial, high-gloss domestic paint and has switched from canvas to aluminium and sheets of melamine. His first comprehensive series "Doors", 1988–1992, reproduces the double swing-doors found in hospitals and other public buildings. The size of the pictures – pared down and abstracted to right angles and a few circular shapes – corresponds to the actual size of the doors depicted. From this point of view, Hume's door paintings are also an expression of the confrontation with the difference between representation and what is represented. Following a brief phase in which he created works like "Housewife Sculpture", 1992, from washbasins and wire netting, and made a video ("Me as King Cnut", 1992), Hume turned to figurative pictures. His models are silhouette drawings taken from pop culture reproductions in periodicals, art books, porn and fashion magazines, which he prepares on A4-format acetate film. Asked as to the selection of his subjects, he has stated that he chooses these for their ability to depict beauty and feeling. This can be seen particularly clearly in the pictures painted from photographs of sculptures in Mussolini's Olympic stadium in Rome ("Hero", 1993; "Vicious", 1994, and "Love Love's Unlovable", 1994). It is also evident in his female portraits, plant and animal subjects, and even in his abstract, psychologically ambiguous works, which sometimes recall Rorschach tests. In all these works, Hume achieves a conscious balancing act between cultural triviality, emotion and beauty.

Y. D.

01

02

03

01 BRACELET, 1997. Enamel paint on aluminium panel, 230 x 161 cm. **02 KATE,** 1996. Gloss paint
and paper on aluminium panel, 209 x 117 cm. **03 VICIOUS,** 1994. Enamel paint on aluminium panel, 219 x 180 cm.
04 AVERY, 1997. Enamel on aluminium panel, 198 x 164 cm.

PIERRE HUYGHE

1962 born in Paris / lives and works in Paris, France

"Everything you look at, any object whatsoever, or image, has been thought about, selected and been subject to huge activity."

Films have different realities. We see them in the original language or dubbed; their effect varies when they are first shown and when they are viewed decades later, and they may be cut differently for television and cinema. Pierre Huyghe deals with these aspects, separating out the different levels of the experience of watching films. In "Dubbing", 1996, we see a group of people who are clearly concentrating hard on the dialogue of a film that can be read in subtitles on the lower margin of the screen. We are watching the dubbing of a film, its content revealed only through the lines of text and the lines of dubbing actors. Though we never actually see the film, we can follow its narrative structure, its gripping moments and quieter episodes. In "Atlantic FRA/GB/D–1929" of 1997, Huyghe simultaneously shows three versions of the same film in different languages. It dates from the early days of sound film, when there was no dubbing and films had to be made in the appropriate language by a different cast of actors using the same sets. Likewise confusing but in a different spatial and temporal context, are Huyghe's large billboard works. A picture of a café, for example, is displayed on the outside wall of the same café. Thus Huyghe presents overlays in time. Diverse things happen at diverse moments, even with the same material or in the same place. Witnessing this process, the viewer begins to realise that reality eludes every kind of documentation. C. B.

01 **"MULTI-LANGUAGE VERSIONS" (ATLANTIC FRA/GB/D – 1929),** 1997. Simultaneous triple video projection.
02 **RUE LONGVIC (BILLBOARD, DIJON),** 1995. Poster offset. Installation view, "Cosmos", Le Magasin – Centre National d'Art Contemporain, Grenoble, France, 1995.

HENRIK PLENGE JAKOBSEN

1967 born in Copenhagen / lives and works in Paris, France, and Copenhagen, Denmark

"For me, art should not restrict itself to formal questions. It should represent an alternative, not an assertion. Maybe I'm idealistic, but I think art should be an instrument of criticism."

Certain themes circulate, almost virally, in Henrik Plenge Jakobsen's works and through his artistic methods. The human body as matter, its relation to authority and to the social body, is a key approach to his world of subversion and ecstasy. These quantities, as constituent parts of the art work's ethical status (or lack of it), are resolved in discussions of the viewer's role and the function of the work. "Laughing Gas Chamber", 1996, is a morbid joke, but also more than just that. It is a plywood chamber where two people at a time can inhale laughing gas through valves in the wall, and get high. The laughing gas changes the viewer's perception. Thus, the fact that the gas chamber is a product of the anti-human forces of industrialization appropiated for programmes of social control raises questions of manipulation and seduction. The beholder's expectation of the work is mechanised by the calculated chemical effect of the laughing gas. Experimental science as an ecstasy of limits is the subject of the "Diary of Plasma", 1996, an ongoing video/publication/installation project. Here the artist presents himself as a kind of latter-day Dr. Frankenstein in a role that has become deadlocked in a blind alley of psychosis. The "Diary of Plasma" is a work that counters the utopian expectations of experimental science. Medical science is associated with caprice and chaos rather than healing and health. Thus Henrik Plenge Jakobsen's art constitutes a tenacious intervention in the structures that determine systems,

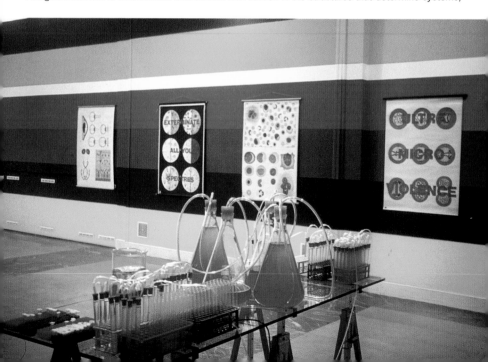

01 NEUTRON, 1995. Installation view, "Neutron, Aperto", ESAD/FRAC Champagne-Ardennes, France, 1995.
02 EVERYTHING IS WRONG, 1996. Walldrawing, acrylic paint, c. ø 250 cm.
03 TEACHER, 1997 (in collaboration with Jes Brinch). Installation view, "Human Conditions", Kunsthalle, Helsinki, Finland, 1997.

and throws doubt on our understanding of the body and its rights in our time of a period of rapid and radical change.

L. B. L.

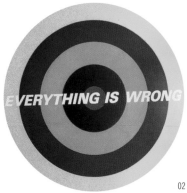

02

◄ 01 / 03

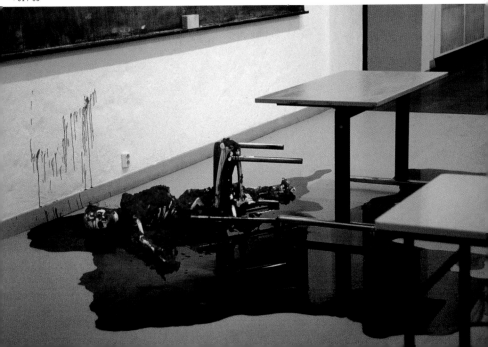

MIKE KELLEY

1954 born in Detroit (MI) / lives and works in Los Angeles (CA), USA

"Artists are people who are allowed a certain social privilege to act out in ways that adults aren't supposed to act out."

A central theme of Mike Kelley's performances, installations, drawings and texts are the "systems of belief", which he calls "propaganda – gone – wrong". His works include a broad spectrum of the most diverse sources ranging from Christian iconography, Surrealism, psychoanalysis and Conceptual Art to the American hippie and punk movement, trash culture, folklore and caricature. Kelley was mainly known as a performer, but achieved international recognition through his multi-part project "Half a Man", 1987–1991. It included worn-out dolls, shabby soft toys, crocheted blankets and ghetto blasters. Kelley saw in the rag toys idealised, sexless models by means of which children were to be adapted to family and social norms. The evidence of intense usage became for Kelley an image of the way compulsions are passed on from one generation to the next. Thus in "Educational Complex", 1995, a miniturized reconstruction of all the educational and training institutions he had passed through, Kelley alluded to the repressed traumas of his own life. This was a form of historiography which, like his project with Tony Oursler about their common experiences with a punk group ("The Poetics Project", 1997), reflects the

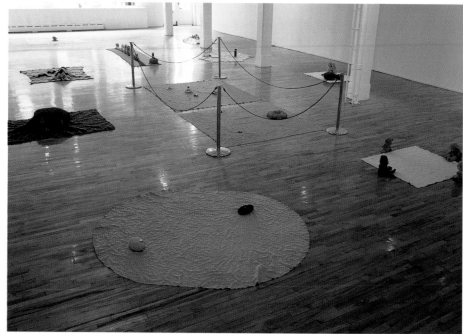

processes of remembering. For every forgetting seems to have its price. In "Pay for your Pleasure", 1988, the viewer passed along a corridor of portraits and quotations from writers and philosophers only to arrive at the self-portrayal of a mass murderer as a clown. Seemingly established relations between enjoyment and the feeling of guilt, suppression and sublimation, apparent normality, voyeurism and the so-called "other", are opened up in Kelley's projects through grotesquely comic exaggerations, and shown in their complex contradictoriness. A. W.

01 INSTALLATION VIEW, Metro Pictures, New York (NY), USA, 1990.
02 INSTALLATION VIEW, Jablonka Galerie, Cologne, Germany, 1991/92.

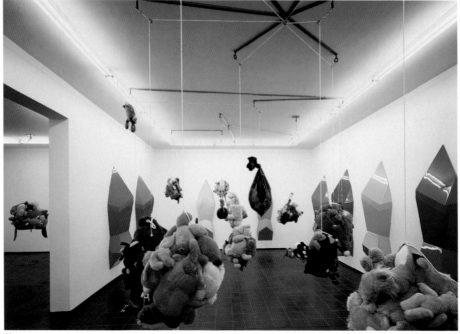

MARTIN KIPPENBERGER

1953 born in Dortmund, Germany / **1997** died in Vienna, Austria

"You can't cut off your ear every day. Do a Van Gogh here, a Mozart there.
It's hard enough just having to keep checking over what you do do."

Martin Kippenberger's multifarious work embraces drawings, paintings, sculptures, installations, artist's books, catalogues, posters, invitation cards, performances and curatorial activities. His approach featured an integrated and participatory process often carried out in collaboration with a close network of assistants, friends and fellow artists. Consciously provocative in his work, he developed an elaborate concept of aesthetics based on bad taste. His preoccupation with particular topics could be triggered off by a variety of different sources. The trivial and the subcultural were for him as relevant as outstanding examples of art history. Thus he was inspired by some of Henry Moore's works to create his own pictures and sculptures, whose titles (e. g. "Familie Hunger" [Hunger Family], 1985) in particular suggest they should be treated as ironic commentaries. He also developed a comprehensive series embracing different media, with its own catalogue, on the theme "Das Ei in der Kunst und im Alltag" (The Egg in Art and Everyday Life), 1995–1997. For his project "Metro-Net. Subway Around the World", 1993–1997, he installed entrances to an imaginary underground railway in various sites around the world, for instance on the Cycladean island of Syros and in Dawson, Canada. On the occasion of "Skulptur. Projekte in Münster 1997", he placed a huge underground railway ventilation shaft on a green meadow, which occasionally emitted sounds of passing trains. For documenta X, he designed another, mobile, entrance to this world-encircling underground railway that existed only in his imagination. Y. D.

01 TRANSPORTABLER U-BAHN-EINGANG (CRUSHED), 1997. Aluminium, stainless steel, 295 x 850 x 215 cm.
Installation view, Metro Pictures, New York (NY), USA, 1997.
02 PORTRÄT PAUL SCHREBER, 1994. Oil, silkscreen, plexiglass on canvas, 240 x 200 cm.

JEFF KOONS

1955 born in York (PA) / lives and works in New York (NY), USA

"Art is communication – it's the ability to manipulate people. The difference with show business or politics is only that the artist is freer."

Jeff Koons, the nice boy from next door, who earned the money for the production of his first works of art as a successful stockbroker, was the absolute superstar of the hectic art scene of the 1980s. First, he placed brand-new vacuum cleaners ("The New", 1980) in glass cases that looked clinically clean and were illuminated with cold neon lighting. The "Equilibrium Tanks" followed in 1985. These were filled with water like an aquarium, and basketballs floated in the middle of them. One year later, he surprised the art market with figures of shiny high-quality steel. At the pinnacle of his fame (1991), Koons married the Italian porn star Cicciolina. The "Made in Heaven" series (1989 onwards) testify to the joys of sex with her, reproducing the delightful event down to the last detail in gigantic pictures and sculptures. Still a media star, Jeff Koons continues to attract the attention of the art world today. His works are perfectly executed, with no expense spared. They display a sophisticated mix of kitsch, modernity and sex. They upset taboos, but not so much to shock as to reveal the beauty in the provocation. Jeff Koons hit the taste of a newly rich yuppie generation better than anyone. After 1992 the fuss died down and the marriage with Cicciolina also hit the rocks. Koons then spent quite some time working on a new project. "Celebration" comprises twenty large sculptures and huge paintings. It was presented in Berlin's Guggenheim Museum in 2000.

C. B.

01

01 PUPPY, 1992. Live flowering plants, earth, wood, steel, 12.4 x 8.3 x 9.1 m. Installation view, "Made for Arolsen", Schloß Arolsen, Arolsen, Germany, 1992. **06 RABBIT,** 1986. Stainless steel, 104 x 48 x 30 cm.

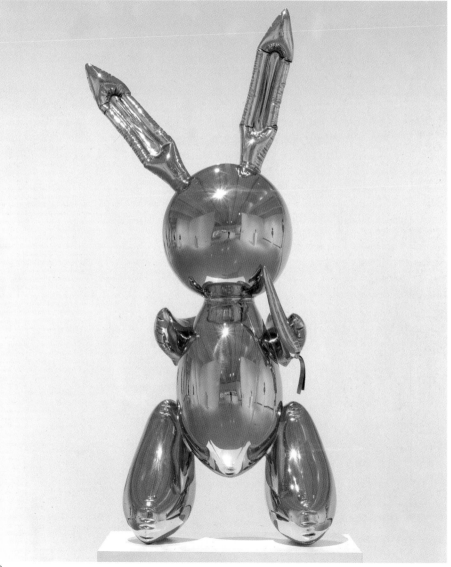

BARBARA KRUGER

1945 born in Newark (NJ) / lives and works in Los Angeles (CA) and New York (NY), USA
"I try to deal with the complexities of power and social life, but as far as the
visual presentation goes, I try to avoid a high degree of difficulty. I want people to be drawn
into the work."

Advertising, propaganda and missionary appeals work like magnets. If they are successful, they
catch the masses by the throat, draw them close and do not let them go again. Barbara Kruger throws
hackneyed messages of this kind at consumers and the masses, to those seeking a meaning: "pray like
us", "fear like us", "believe like us". The slogans are frequently articulated as appeals that Kruger mounts
in strong, usually white and red inscriptions. Her combination of typography with black and white photog-
raphy, a symbol for the positive-negative schema of the quoted messages, has become her trademark.
She has mass-produced posters, T-shirts and shopping bags, stuck posters on outside walls and advert-
ising spaces. Ever since her first texts in Times Square annoyed the people of New York in 1983 ("I am
not trying to sell you anything"), Kruger's concept has been both public and political. For instance, she
designed the poster for the women's rights demonstration in Washington of 1989 ("Your Body is a Battle-
ground"), wrote a feminist pamphlet translated into many languages ("We do not need any new heroes")
and published various books on such themes as discrimination against minorities and AIDS. In the 1990s
concrete opposition has given way to a deeper thoughtfulness, which highlights the history of mass pro-
paganda and new strategies of psychological persuasion. Currently Kruger's work is multimedia. She

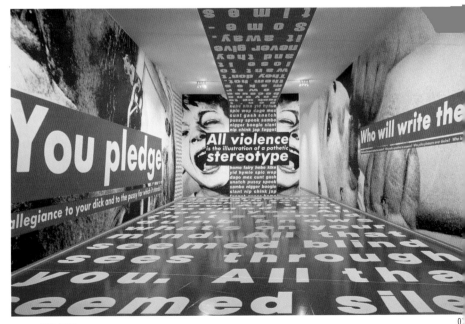

01 INSTALLATION VIEW, Mary Boone Gallery, New York (NY), USA, 1991.
02 UNTITLED (YOU CAN'T DRAG ...), 1990. Photographic silkscreen, vinyl, 277 x 389 cm.
03 POWER PLEASURE DESIRE DISGUST, 1997. Multi media installation,
Deitch Projects, New York, 1997.

supplements written messages with acoustics, and photography with video projection. Back in the exhibition room, she encircles the public ("YOU") with a powerful show of targeted attacks. Confrontation has become claustrophobia. In "Power Pleasure Desire Disgust", 1997, Kruger no longer attacks the public's attitudes but their zones of intimacy. S. T.

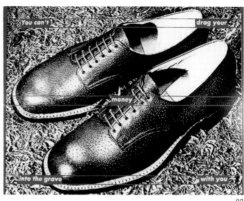

02

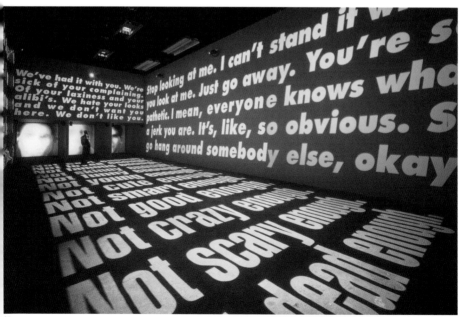

03

PETER LAND

1966 born in Aarhus, Denmark / lives and works in Copenhagen, Denmark

"Video allows me to use myself as different figures. In front of the camera, I'm able to enact a private fantasy as a social statement."

At the beginning of Peter Land's early video performances there stands the cryptic comment: "What would be the last thing in the world I'd be ready to do, I wondered. How could I put myself in doubt?" His answer was total exposure, which he carried out in two experiments on himself. In the first, he endeavoured to tempt two strippers to his sex show in his sitting room in front of a running camera ("Peter Land the 6th of February", 1994), while in the second he filmed an amateurish performance of himself as a striptease dancer ("Peter Land the 5th of May" 1994). This endless, alcohol-soaked, anything-but-erotic display of his own nakedness made Land known overnight. Since then, his work has been dominated by startlingly touching and often embarrassing pictures in which he presents prototypical situations of degradation and defeat. In unending repetition, he puts before us a variety of sequences of scenes that go to extremes to conjure up a condition of self exposure and failure, in great detail and with total inevitability. Land's videos are reminiscent of the sitcom of silent films and slapstick, but are so precisely constructed that the neuralgic point of downfall stands only for itself, thereby becoming a statuesque image. His plots supply interpretations that allow for both general human identifications as well as reflections of art imagery. External falls are guided inwards in melodramatic fashion, often exaggerated by music, as for example in the relentlessly repeated plunge down a staircase ("The Staircase", 998), which against the contrast of a dark starry sky appears like plunging out of the world itself. S. T.

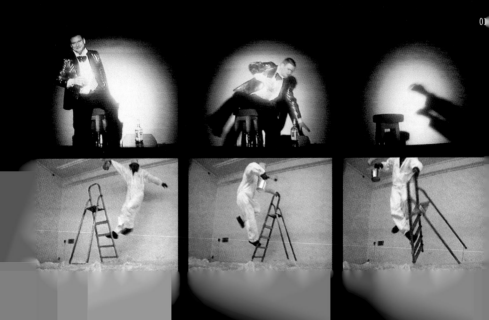

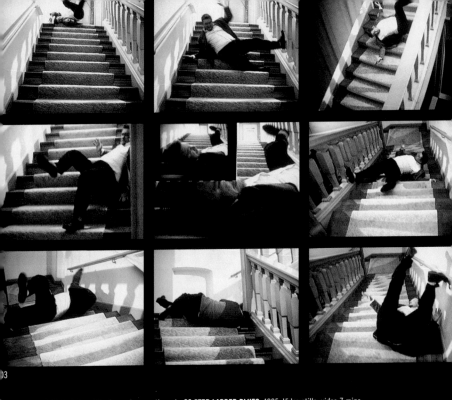

03

1 PINK SPACE, 1995. Video stills, loop, plays continously. **02 STEP LADDER BLUES,** 1995. Video stills, video 7 mins.
3 THE STAIRCASE (THE STAIRCASE), 1998. Double video projection, video stills.
4 PETER LAND THE 5TH OF MAY 1994, 1994. Video stills, video 25 mins.

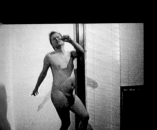

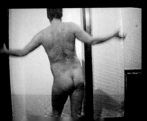

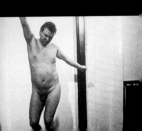

LOUISE LAWLER

1947 born in Bronxville (NY) / lives and works in New York (NY), USA

"Why I resist interviews: they foreground the artist – tell too much about what wouldn't be known when confronting the work."

According to Louise Lawler, art is created through a collective process. Not only artists, but also critics, curators, dealers and collectors participate in the creation of aesthetic value and significance. Since the late 1970s, Lawler has focused on the apparently tangential mechanisms of the presentation and marketing of art: the institutional framework. Her initial, often ephemeral projects, such as the "Book of Matches" and her later photographs, gallery and museum installations, examine individual elements of the cultural apparatus – invitation cards, lighting, captions, installation photos – shifting their meanings through subtle modifications. Lawler often combines her own works with those of other artists, as she did in 1982 in the New York gallery Metro Pictures. By taking on "curatorial" tasks there, she removed the customary division of duties between gallery owner and artist. She saw the works of art as aesthetic signs that could take on other meanings according to their context. Her "Arrangements of Pictures" thus depict art works in private and corporate collections as well as in auction houses, indicating their function as commodities, luxury goods and status symbols. She uses inscriptions which are sometimes stamped

01 EXHIBITION, 1987. Printed glasses with text "You Could Hear A Rat Piss On Cotton. Charlie Parker", glass shelves, paint, 2 cibachrome photos of The Museum of Contemporary Art, Los Angeles (CA), USA. 02 POLLOCK AND TUREEN ARRANGED BY MR. AND MRS. BURTON TREMAINE, CONNECTICUT), 1984. Colour photo, 41 x 51 cm. 03 PRODUCED IN 1988, PURCHASED IN 1989; PRODUCED IN 1989, PURCHASED IN 1993, 1995. Cibachrome (museum box), 114 x 149 cm. 04 I–0, 1993–1998. Cibachrome (museum box), 50 x 59 cm. 05 PINK, 1994/95. Cibachrome, 120 x 151 cm.

on the passe-partouts, to reveal further interpretations. For instance, in a work of 1988 she annotates two of Warhol's photographs "Round Marilyn" with the questions "Does Andy Warhol make you Cry?" or "Does Marilyn Monroe make you Cry?", an ironic allusion to the emotional expectations that are often associated with the reception of art. Often, instead of putting her name in the foreground as the determining factor in the valuation of her art, she inscribes the name of a curator, art adviser or a museum or administrative employee. The autograph as the essence of authorship is decentralised, and with it the idea of artistic autonomy as a requirement for the circulation of art. A. W.

ZOE LEONARD

1961 born in New York / lives and works in New York (NY), USA

"You would like to contribute to making a world in which you can just sit around and think about clouds. That should be our right as human beings."

The work of the photographer Zoe Leonard stands between two poles whose opposition to one another almost dissolves in her hands – the ostentatious language of political activism and the sensitive tonality of poetic fiction stand side by side and equal. As a lesbian feminist she is committed to the struggle for freedom and the recognition of marginal groups. At the same time, her photographic view of the world is an extremely dreamy one, as is seen in her wave pictures "Water #1 + #2" of 1988. Leonard created one of her best-known works as a member of the artist collective "Gang" – the poster "Read My Lips", 1992, which depicts a woman's vagina accompanied by the sentence: "Read my lips before they are sealed." The text alluded to a law forbidding American doctors to use the word "abortion". The fact that a lesbian feminist put the vagina ostentatiously but apparently without emotion at the centre of the picture, raises further questions: who has control over the female body and over pictures of women? What is achieved by the censorship of homoerotic subjects? How can a female sex organ be represented without eroticism? The role of women also stands at the centre of the photo series "Fae Richards Photo Archive", 1993–1996. The artist lovingly compiled the fictitious biography of a black Hollywood actress at the beginning of the 20th century. Role allocation and mechanisms for the exclusion of blacks prove to be social constructs, in which the lightning and settings of well-known film stills are utilised. Why, for instance, are pictures of black actresses usually underexposed while white men are brightly lit? But for all the political rhetoric, the work is also fascinating because of its occasionally senti-mental nostalgia – the objective of all battles is simply "winning back beauty". R. S.

01 / 02 UNTITLED, 1992. Installation views, Neue Galerie, documenta IX, Kassel, Germany, 1992.
03 / 04 STRANGE FRUIT (FOR DAVID), 1992–1997 (details). Different formats, 297 elements: peels of oranges, lemons, grapefruits, avocados and bananas; thread, needles, zips, buttons, wax, plastic, hook, string, fabric.

ATELIER VAN LIESHOUT

Established in **1995**. Joep van Lieshout: **1963** born in Ravenstein, The Netherlands / lives and works in Rotterdam, The Netherlands

"I couldn't care less what people call it, as long as we can make what we want."

Founder and source of ideas for the Atelier van Lieshout is the artist Joep van Lieshout. He has adopted the term "Atelier" since 1994, to stress that his works are created in cooperation with many collaborators. His workshop supplies not only standard shelves, tables and chairs; the business is also geared up to fitting out entire bathrooms or kitchens. Van Lieshout's furniture and architecturally fitted furnishings are intended to be understood and used as part of everyday culture. As good value for money produced rapidly in unlimited quantities, they are spared any snooty upmarket aura. Along with furnishings for the home, van Lieshout is best known for his mobile homes. In addition to these, he makes weapons, distills alcohol and is a racing driver. His liberal concept of "art" also extends to his equipment for slaughtering animals. At exhibitions, he displays photos of the slaughtering process and preserved or smoked meats as well as a visual representation of self-catering and the slaughter ritual. All in all, with his furniture, sanitary units and sleeping accommodation, van Lieshout's artistic output covers everything that you need in life – or to survive. Many of his works are charged with sexual innuendos. This applies not only to the early "Biopimmel" (Biowillie), 1992, but also to the great beds or the "Wohnmobile für Liebesspiele" (Mobile Homes for Love Play). Van Lieshout's lockable enclosures are intended to enhance people's sexual energy and derive, like his "Sensory Deprivation Helmets", from the work of the psychologist and sexologist Wilhelm Reich. Lieshout's work follows Reich's theory in acclaiming libidinous needs and seeing a comprehensive, cosmic life force in them. Y. D

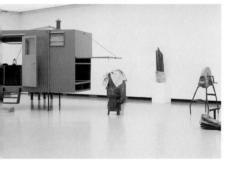

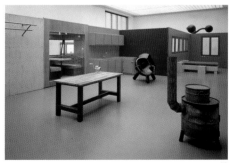

1 / 02 CASTMOBILE, 1996. Interior, mixed media,
,2 x 11,3 x 9,5 m.
3 INSTALLATION VIEWS, Museum Boijmans Van Beuningen,
otterdam, The Netherlands, 1997.

SHARON LOCKHART

1964 born in Norwood (MA) / lives and works in Los Angeles (CA), USA

In her films and photos Sharon Lockhart often works with allusions to film classics, and many of her photographs have the atmosphere of film stills. The photo series "Shaun", 1993, which was made in connection with her film "Khalil, Shaun, A Woman Under the Influence", 1994, is distinguished by a perceptible discrepancy between the visible surface and the psychological content. The boy's unconcerned facial expression contrasts with the wounds – applied by a mask-maker – that cover his body. Lockhart often works with young people who are in the transitional stage between childhood and puberty or puberty and adulthood. Lockhart presents scenes in which the actors' characterization does not accord with the actions performed. For instance, the age of the mutually embracing and kissing children from her photo series "Audition", 1994, in which Lockhart presented a scene from "L'Argent de Poche" (Small Change) of 1975 by François Truffaut, does not fit the action reproduced and lends these works an ambivalent atmosphere. In her 63 minute-long film "Goshogaoka", 1997, she observes from a stationary camera position girls of a Japanese basketball team exercising. For all the documentary dominance there increasingly evolves a choreography over a ground of the noises of body movements and later computer music. Like many of her works, "Goshogaoka" is conditioned by the simultaneous emphasis on formal aspects (narrative structure) and on themes (representation). Y. D

01 LILY (APPROXIMATELY 8 AM, PACIFIC OCEAN), 1994 (left); **JOCHEN (APPROXIMATELY 5 PM, NORTH SEA),**
1994 (right). 2 C-prints, 79 x 229 cm. **02 UNTITLED,** 1996. C-print, 130 x 104 cm.

SARAH LUCAS

1962 born in London / lives and works in London, England

"It's a bit like 'Escape from Alcatraz', you have to get a nail-file if you can get hold of one, saw the bars through. You have to use what you've got, and either it does the job or it doesn't. It is articulating your way out of something."

Sarah Lucas first came to prominence with her large-scale collages consisting of photocopies and cuttings from newspaper articles. She combines page-three girls from the tabloid press with the grotesque headlines of sensational journalism. In some of these works, she integrates the self-portraits that have become one of her trademarks. She photographs herself in assumed masculine poses: sitting on a staircase with her legs spread; wearing a leather jacket, sunglasses and stout shoes; or suggestively eating a banana. Items of food and everyday objects are arranged as still lifes or photographed, quite often taking on sexual connotations. In one of her best-known works, "Au Naturel", 1994, for example, a cucumber protudes from an old mattress flanked by two oranges; a female counterpart is provided by a battered metal bucket and two melons. Lucas often creates a crude effect, communicating an unflinching, sometimes aggressive directness in her handling of themes like sexism or violence through abstruse or outrageous images. At the beginning of her career she was regarded as a feminist artist, but her installations "Is Suicide Genetic?", 1996, or "Car Park", 1997, demonstrate her interest in a wide range of social

01 CAR PARK. Installation view, Museum Ludwig, Cologne, Germany, 1997. **02 WHERE DOES IT ALL END?,** 1994. Wax and cigarette butt. **03 SMOKING ROOM,** 1996. Installation view, "Full House", Kunstmuseum Wolfsburg, Wolfsburg, Germany, 1996.

problems such as genetic research and the social causes of vandalism. Lucas once said in an interview that her work is about the possibility of describing the world, a claim borne out by the diversity of her themes.

Y. D.

02

03

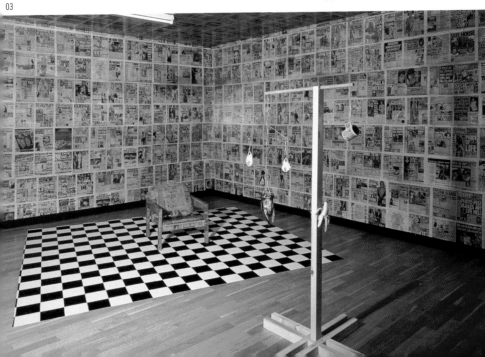

MICHEL MAJERUS

1967 born in Esch, Luxemburg / lives and works in Berlin, Germany

"My work operates precisely on the assumption that every claim to 'authentic' culture and lifestyles is illusionary."

Michel Majerus's exhibitions are concentrated charges of quotations, styles and images. At first glance, it is not easy to grasp their point. The structures are classical enough: regular rectangles or ceiling-high formats like those utilised by Modernism at its most self-assured. But their use seems sacrilegious, an injury to the dignity of these forms. Majerus quotes classic painters, particularly the heroes of the large format – American Modernists such as Frank Stella, Ellsworth Kelly, Andy Warhol or Jean-Michel Basquiat – and Donald Judd, Robert Morris and Lawrence Weiner. Alongside these, he places functional aesthetic forms, print media and rapidly painted signs. Majerus is no longer concerned with the introduction of the real and banal into art, nor with that battle against the end of painting that jumps out at us from each of Gerhard Richter's paintings, for example. From Majerus's perspective, all visual media have acquired equal value and should simply be viewed as co-existing simultaneously. In his first major exhibit-

ion, in 1996, the exhibition space itself was part of the thesis. In contrast to the gilded rooms of the Basle Kunsthalle, he laid metal grilles on the floor, positioning his pictures inside them like a backdrop, or painting them directly on the walls. This produced a new dimension of perception. The museum ceased to be a place of the past, of nostalgic memories and conservation, and authorship lost its importance: the pictures were available in the here and now.

S. T.

01 **"FERTIGGESTELLT ZUR ZUFRIEDENHEIT ALLER, DIE BEDENKEN HABEN",** installation view, neugerriemschneider, Berlin, Germany, 1996. **02 KATZE,** 1993; **WEISSES BILD,** 1994. Installation view, Kunsthalle Basel, Basle, Switzerland, 1996.

◄ 01 / 02

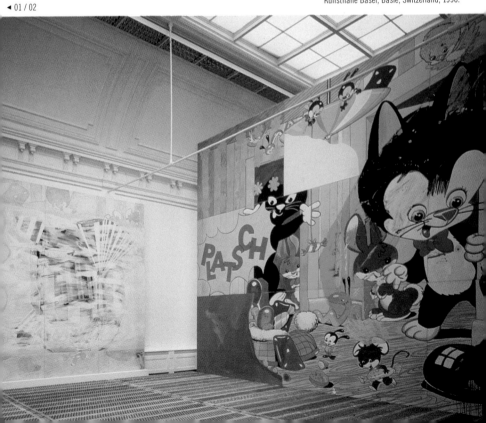

PAUL MCCARTHY

1945 born in Salt Lake City (UT) / lives and works in Los Angeles (CA), USA

"I have always had this fascination with film and television, but I never wanted to become a part of the industry: my interests are more directed towards a parody or mockery of it."

Since the late 1960s Paul McCarthy has been using a variety of different media. He employs "painting as action", performance, installations that comprise the spatial context of his actions, and the camera and video camera as instruments that steer the viewer's sometimes voyeuristic attention. In "Bavarian Kick", 1987, McCarthy extended his formal repertoire with sculptures, partly equipped with motors, which act on his behalf. At the centre of his performances stand the conflicts or "dilemmas" of the hybrid and cliché-ridden characters which he assumes with the help of masks and disguises: a politician ("Carter Replacement Mannequin", 1980), a housewife ("Mother Pig", 1983) or an artist ("Painter", 1995). McCarthy's actions are always sexually loaded and are drastically theatrical stagings of processes and deeds that are occasionally taboo, like birth and death, coitus, sodomy and masturbation. Frequently, as in "Bossy Burger", 1991, or "Heidi", 1992 (with Mike Kelley), they refer to the patriarchal family structure as a source of profound disturbances. Unlike Viennese Actionism, with which McCarthy's works are sometimes associated, he is not concerned with the authenticity of suppressed feelings. His theme is the moulding of individual behaviour through the mass media and social structures. The body is one of the focal points where these influences pile up. McCarthy's points of reference are the simulacra of an (ab)normal world such as Disneyland, B-movies, TV series and comics. His obsessive use of manufactured fluids like ketchup or mayonnaise as a substitute for bodily fluids is a mark of the thoroughly alienated condition of the (American) individual. He stages hopeless situations that reflect social power relations in order to subject them to his "tasteless", symbolic and tragicomical ravages. A. W.

01 / 02 / 03 / 04 **SANTA CHOCOLATE SHOP,** 1997. Film stills.
05 BARTENDER WITH PIG HEAD. Mixed media, 353 x 485 x 279 cm.
Installation view, "SALOON", Luhring Augustine, New York (NY),
USA, 1996. **06 TOMATO HEADS,** 1994. Installation view, Rosamund
Felsen Gallery, Los Angeles (CA), USA, 1994.

▼ 06 / 05

TRACEY MOFFATT

1960 born in Brisbane, Australia / lives and works in Sydney, Australia, and New York (NY), USA

"Images: colour, light, surface, composition, design; subject matter being secondary."

The half-aboriginal film-maker and photographer Tracey Moffatt was adopted by a white family as a baby, and grew up in an Australian workers' settlement. Her knowledge of visual culture was derived from television. Soap operas, talk shows, American films and sports programmes contributed in equal measure to her view of the world, as did her sense of being an outsider in her own family. Both experiences find expression in her art. Highly poetic, almost surreal moments together with banal clichés and political statements constitute an exciting mix. For instance, in her early short film "Night Cries: A Rural Tragedy" of 1989, Moffatt uses theatrically stylised images to tell the story of a coloured daughter looking after her dying adoptive mother, while torn this way and that between feelings of affection and rage. The assimilation of the aborigines and education in accordance with white values is handled here with the devices of Hollywood mother-daughter melodramas. But the artist also uses avant-garde techniques in the film, such as the constant shifting of narrative levels and an almost photo-realistic focus. "Night Cries" is thus as consciously "torn apart" as the artist's multicultural identity. It is the simultaneity of poetic atmosphere, artificial composition and political controversy that lends Moffatt's later photo series their power. In "Guapa (Goodlooking)", 1995, she shows female roller-skaters participating in a special kind of race, the point of which is to knock one's opponents out of the contest. Crude violence, seemingly weightless motion and the reversed cliché of the weaker sex combine to form a dramatic allegory that is not intended to be open to straightforward interpretation. R. S.

Doll Birth, 1972 His mother caught him giving birth to a doll. He was banned from playing with the boy next door again.

Birth Certificate, 1962 Giving the fight her mother threw her birth certificate at her. This is how she found out her real father's name.

Useless, 1974 Her father's nickname for her was 'useless'.

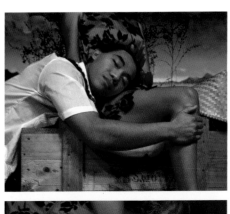
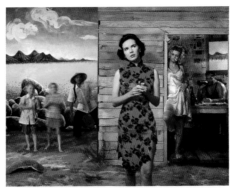

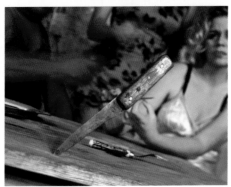

02

01 SCARRED FOR LIFE, 1994. From left to right: **DOLL BIRTH,** 1972; **BIRTH CERTIFICATE,** 1962;
USELESS, 1974. Series of 9 offset prints, 80 x 60 cm (each). **02 SOMETHING MORE,** 1989. From left to right, top:
SOMETHING MORE 3, 1989; **SOMETHING MORE 1,** 1989; bottom: **SOMETHING MORE 7,** 1989;
SOMETHING MORE 5, 1989. Series of 6 cibachromes and 3 b/w photographs, c. 100 x 130 cm (each).

MARIKO MORI

1967 born in Tokyo / lives and works in Tokyo, Japan, and New York (NY), USA

"My work is a revelation of thought. Also, I enjoy projecting
the esoteric gesture through the inner world."

In the mid-1990s, Mariko Mori landed on the art scene like a seductive being from a world yet
to come. She appears in her photographs dressed like a futuristic comic-book figure who refuses to be
anywhere but in the appropriate surroundings. She celebrates herself as an art product, as a star born
out of the worlds of both music and fashion, who well knows that stardom is usually of short duration.
After the performance shoots, her costumes are sealed in large plexiglass capsules that will remain un-
opened for at least 25 years. Mori's works are becoming increasingly extravagant: first they developed
into pictures with several layers that gave the impression of movement, then they became videos played
out to insistent music, and finally a 3-D film has emerged. Most recently she has stylised herself from
her star act to a kind of supernatural being surrounded by little flying Buddhas. She cleverly succeeds in
mixing visions of fashion and architecture in the style of the 1960s and 70s with the technical perfection

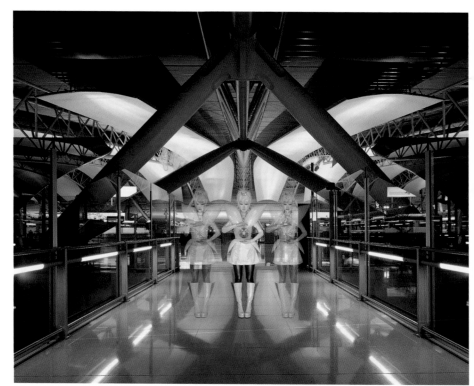

01 LAST DEPARTURE, 1996. Cibachrome print, aluminium, wood, smoke aluminium, 213 x 366 x 8 cm.
02 EMPTY DREAM, 1995. Cibachrome print, aluminium, wood, smoke aluminium; 6 panels, 2.7 x 7.3 m x 8 cm.
03 ENTROPY OF LOVE, 1996. Glass with photo interlayer; 5 panels, 305 x 610 x 2 cm; each panel, 305 x 122 x 2 cm.

of today. Her message is the necessity of believing in utopias, conveyed in works that are neither ironic nor naive, but try to indicate in an optimistic and interesting way that it is pointless to attempt to stop time. The overall impression of fun is inescapable. C. B.

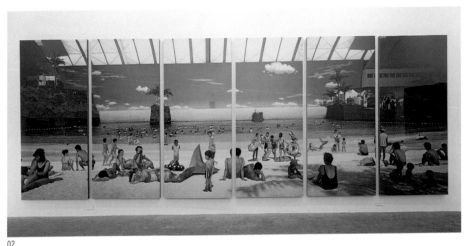

02

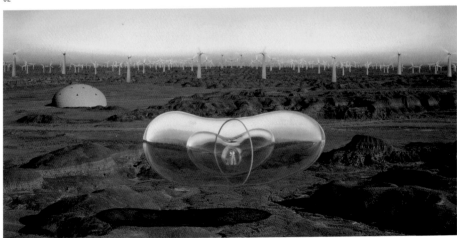

03

ALBERT OEHLEN

1954 born in Krefeld, Germany / lives and works in Hamburg and Cologne, Germany

Developing in the area of tension between figurative and abstract art, Albert Oehlen's work is subject to continual change. In his paintings, collages and drawings he demystifies art, rendering his artistic methodology transparent. His painting is the expression of his thoughts on art as a medium, a criticism of its veneration and an analysis of its artistic and social capabilities. This was already true of his early figurative works, which in the 1980s were identified as belonging to the "New Wild Painting", and of the following cycle "Farbenlehre" (Colour Theory), in which he reduced his palette to the three primary colours red, yellow and blue. This limitation of subjective colour selection finds its counterpart in Oehlen's deliberate renunciation of any moral or artistic evaluation of his themes and subjects, whether he is

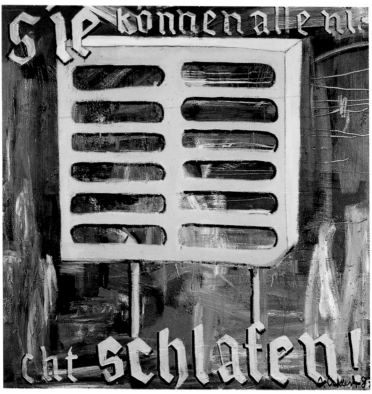

01

01 **ABSTRAKTES BILD 24 B**, 1987. Oil, gloss on canvas, 200 x 200 cm.
02 **UNTITLED**, 1993. Oil on fabric (imprinted), 240 x 240 cm.

dealing with a portrait of Adolf Hitler, representations of animals, or portrayals of everyday situations. In his works between 1985 and 1988 he put texts in historicised script opposite figurative objects and people, thus creating an additional level of content. Often, the smudged and glazed patches of colour that dominated his abstract pictures in the late 1980s appear in the background of these works. Since the early 1990s, Oehlen has used computer painting programs. By this means he not only extends his formal repertoire but also offers additional comments on the theme of artistic authorship. This also applies to his current coloured computer collages, which are similar in character to his early provocative and irreverent oil paintings. Y. D.

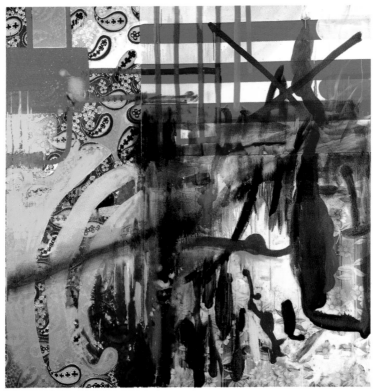

02

GABRIEL OROZCO

1962 born in Jalapa, Veracruz, Mexico / lives and works in Mexico and New York (NY), USA

"First of all I'm a recipient and second I'm a producer. Sculpture is that, a recipient."

Gabriel Orozco is a precise and yet poetic recorder of the fleeting and the mundane. His installations, objects and photographs emphasise, in an unpretentious and yet precise way, moments of displacement and the disappearance of space and time. In this way, he "delocalises" his sculptures, as it were, and yet casts a permanent spell over them. Probably his best-known work is "La D. S.", 1993, in which he cut a Citroen lengthwise and put it back together again after removing the centre third of the car. This "slimming cure" lends the Citroen an unexpectedly streamlined shape. But although the car is certainly more elegant in appearance, instead of becoming faster it is dysfunctional. This work is a witty comment both on art and on our faith in technological progress. Reducing the interior of his "Elevator", 1994, likewise prevents motion in an otherwise unaltered readymade. Movement and space are also the two coordinates for Orozco's project "Until You Find Another Yellow Schwalbe", 1995. During a long stay in Berlin, the artist drove through the city on a yellow Schwalbe motor scooter. Whenever he saw another

"Yellow Schwalbe" beside the road, he stood his own alongside it and photographed the pair, so that stasis and dynamics enter into a site-specific dialogue. Other photo works are also concerned with this relationship. For example, his "Leaves on Car", 1992, shows autumn leaves on a car's windscreen, evoking the lapidary everyday lyricism of nature and technology, movement and transience. In his project "Ferris Wheel, Half Sunk in the Ground", 1997, we experience the "shadowy underworld" and "heavenly heights" in just one revolution of the Ferris Wheel in an infinite "Divine Comedy". R. S.

01 OVAL BILLIARD TABLE, 1996. Wood, slate, mixed media, 89 x 309 x 229 cm.
02 LA D. S., 1993. Sutured car: metal, leather, coated fabric, 140 x 480 x 114 cm.

◄ 01 / 02

TONY OURSLER

1957 born in New York / lives and works in New York (NY), USA

"... people are most attracted to the face."

Tony Oursler's figures sometimes have a hard time of it. They are squashed under sofas, chair legs and mattresses, shut up in suitcases and trunks, sometimes hang head-first from the ceiling, or are even speared, lamenting their suffering in semi-darkness. They are made of fabric, but they seem to be alive. Little video projectors give them a living face, and from loudspeakers there sounds an even more insistent voice that complains, calls out for help or simply gives a death rattle. Since 1992 Oursler has in this way been combining features of the theatrical stage so cleverly with those of video art that this has become his unmistakable trademark. It is as though monitors and canvas had suddenly assumed bodily form. Oursler's figures swiftly became the darlings of the public. In a completely different part of his operations he has been very active in working on the Internet. In a recent series the projector's beam impinges on large fibreglass spheres and simply shows an eye looking from side to side. Should the viewer at first believe that he might be the object of attention, it becomes clear as he comes nearer that in reality a television programme is being followed. The monitor is reflected as a small blurred picture in the eye-ball, and this corresponds to the movements of the pupil. Without knowing exactly what it is all about, one feels fear and excitement. But actually the person to whom the eye belongs could feel bored. In this way Oursler demonstrates the mechanisms of the media and at the same time exposes our belief in them.

<div align="right">C. B.</div>

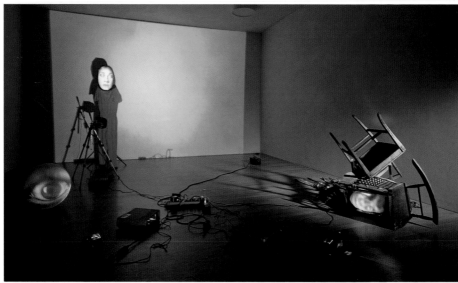

01 CRIMINAL EYE; SKETCHY BLUE; BROKEN. Video, mixed media, dimensions variable.
Installation view, "Matthew Barney – Tony Oursler – Jeff Wall", Sammlung Goetz, Munich, Germany, 1996/97.
02 SUBMERGED, 1996. Projector, VCR, videotape, tripod, wood, plexiglass, ceramic, water, 135 x 28 x 28 cm
(plus equipment). Performance: Tracy Leipold.

JORGE PARDO

1963 born in Havana, Cuba / lives and works in Los Angeles (CA), USA

"There is a lot of more interesting stuff around here than my work, but my work is a model to look at this stuff."

In many of his works Jorge Pardo makes explicit reference to the material situation of an exhibition. We can therefore see his landing-stage "Pier" of 1997 in Münster both as a sculpture in its own right and as an allusion to the tradition over many years of observing the locality of the exhibition. Another example of dealing with the exhibition venue is his design of the exterior façade and the office furniture of the gallery in Berlin that represents him. With other works of Pardo's, too, the utilitarian aspect is in dialogue with genuine artistic enquiry. His lamps, with which he occasionally harks back to the design of the early seventies, his seatings and other items of furniture facilitate an easy approach to the work through their smooth surfaces, organic forms and evocative colours. At the same time Pardo uses his furniture objects to illustrate the distinction between art and design. Pardo designs most of these objects himself, but in some installations he integrates well-known "design classics". The meaning of the supposedly familiar is altered through new associations, and different possibilities are offered to the viewer for his interpretation. His most ambitious project is his own house, which was built in connection with his exhibition organised by the Museum of Contemporary Art in Los Angeles and which for the duration of the exhibition served the museum as an annexe. It was at one and the same time a private dwelling, an exhibition venue and an exhibit. Pardo is interested in the institutional problems connected with this, and also in fundamentally investigating the characteristics of exhibition situations. Y. D.

01 **"LIGHTHOUSE",** installation view, Museum Boijmans Van Beuningen, Rotterdam, The Netherlands, 1997. **02 UNTITLED,** 1997. Sailboat. Installation view, Museum of Contemporary Art, Chicago (IL), USA, 1997. **03 INSTALLATION VIEW,** Neue Messe Leipzig, Leipzig, Germany, 1996 (permanent installation).

01

02

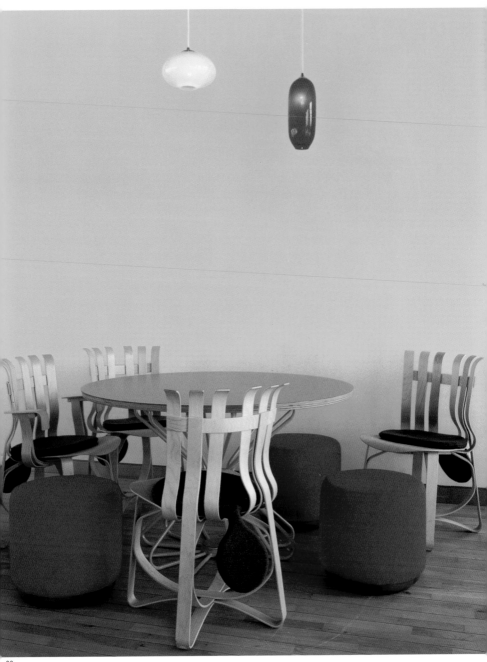

PHILIPPE PARRENO

1964 born in Oran, Algeria / lives and works in Paris, France

Philippe Parreno's art primarily explores the territory between fiction and reality. Images familiar from television or the cinema, such as the town-sign of "Twin Peaks" or the balloon from "Batman" crop up in his exhibitions. In one piece, the characteristic rasping voice of the film director Jean-Luc Godard makes the assertion that a Christmas tree is a work of art: "For 11 months, I was right … this Christmas tree was a work of art for eleven months, and in the twelfth month it was no longer art, it was Christmas." In "Listen to the Picture", 1998, Parreno masked the upper and lower edges of a Taiwanese-language film in black so that only a broad middle section remained visible. The film is thus seen anew, several scenes moreover being accompanied by subtitles. Whether these subtitles correspond to what is happening in the film or reflect a subjective assessment, remains open. The film is also being constantly interrupted by a fictitious advertising spot promoting a Walkman-like apparatus called "Noise Man", which converts loud environmental noises into pleasant melodies. Parreno draws on already existing material, enriching it with his own, mostly narrative ideas. He gives the stories a new setting, focusing our attention on particular aspects, and thus redescribes his own experiences as a recipient. This individual view is presented by Parreno on a highly intellectual and yet entertaining plane. The works may seem skittish at first sight, but after a few moments one senses their profundity.

C. B.

01 UNTITLED (JEAN-LUC GODARD), 1993. Christmas tree, stools, receiver, tape, cassettes. Installation view, "Backstage", Kunstverein in Hamburg, Hamburg, Germany, 1993. **02 WERKTISCHE I UND II (MADE ON THE 1ˢᵗ OF MAY),** 1995. 2 tables, ø 160 cm each, 8 teddy bears, video projector, video cassette, screen. Installation view, "Traffic", capc Musée d'art contemporain, Bordeaux, France, 1996. **03 NO MORE REALITY (BATMAN'S RETURN),** 1993. Vinyl ball, acrylic lacquer, nylon thread, ø 300 cm. Installation view, "Le principe de réalité", Villa Arson, Nice, France, 1993.

01

MANFRED PERNICE

1963 born in Hildesheim, Germany / lives and works in Berlin, Germany

"To start with, the three-dimensional object is, fortunately, there – but then, as a relative, puzzled-up location it dissolves in contradictions and disappears."

Manfred Pernice builds places. The largest of them, like "Sardinien" (Sardinia), 1996 or "Platz" (Place), 1998, take up an entire exhibition room. Alongside these, he is constantly turning out little pocket-sized models that could be designs for other room-sized projects. The size of Pernice's places is irritating in both cases. However much they are bound by realistic details – the facade of a building complete with posters and hoardings, or the interior wall with wallpaper, picture frames and shelves, for example – they remain models, illusions. That is because Pernice twists familiar facts, makes interiors and exteriors mutually contradictory and distorts real-life scales and relationships. Pernice often refers to places he has seen, but always refashions them to his own ideas. In the case of "Sardinien", before the observer takes in the title reference to the holiday island, the illusion is communicated of an interior turned inside out, where wallpaper, picture frames and shelves are fixed to outer walls, to make what ends up to some extent like a highly tumorous form of architecture. Yet in his objects, Pernice succeeds in communicating a profound insight into the nature of building, living and experiencing – into the crazy details and myths of modern living accommodation. The "Platz" that Pernice installed in a small gallery room in 1998 constitutes his most comprehensive metaphor in this regard: it features a rough plywood sheet and four boarded stumps of columns, whose perforated structures appear to sum up basic questions about constructional engineering. Pernice's big idea is the portable place, or the place you can build or erect at home on your shelf. Each functions like a three-dimensional picture postcard of a virtual and yet very real world. S. T.

01 WEINBERG, 1997. Wood, laminated fibre sheet, paint, 110 x 270 x 295 cm.
02 UNTITLED, 1996. Painted cardboard, 8 x 10 x 10 cm.
03 UNTITLED, 1996. Painted cardboard, 12 x 16 x 10 cm.
04 UNTITLED, 1997. Painted cardboard, 12 x 7 x 7 cm.
05 UNTITLED, 1997. Painted cardboard, 12 x 12 x 7 cm.
06 UNTITLED, 1996. Painted cardboard, 7 x 12 x 6 cm.
07 KORREKTURDOSE, 1995. Painted cardboard, 7 x 7 x 12 cm.

01

▶
02 03
04 05
06 07

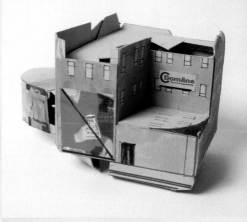

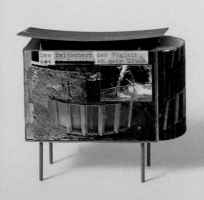

DAN PETERMAN

1960 born in Minneapolis (MN) / lives and works in Chicago (IL), USA

"What interests me in recycled plastic is a certain quality of flow. In our society, plastic generally implies a way of thinking in which all things are disposable. And yet it features in the majority of our most highly prized possessions."

Dan Peterman's projects and sculptures – the latter technically oriented to Minimal Art – are an expression of the way he confronts problems of our post-industrial society, such as consumerism, affluence, ecological pollution and homelessness. For his seemingly interventionist work "Chicago Compost Shelter", 1988, Peterman had a scrapped VW minibus covered with biological waste. The warmth coming from the compost heats the interior of the vehicle, which can then be used in winter as a dwelling by a homeless person. Since the beginning of the 1990s Peterman has been making benches and tables from recycled plastic containers. These are constructed from standardised modules and can be combined at will in different forms. One of his works made using this method is "Running Table", 1997, which Peterman erected in a Chicago park. Not only does it provoke debate on themes such as "Art in Public Places", but it also functions as a social meeting place, raising questions about the social function of art. Whether Peterman constructs a wall from used batteries ("Spending Energy Storing Energy Spent", 1993); purchases the right – under an emission law passed in the USA in 1990 – to discharge a certain quantity of sulphur dioxide into the atmosphere ("Sulfur Cycle", 1994); or has a solar-powered car driven round a park threatened by the building of museum extension ("Run Until Dead", 1998), his interest tran-

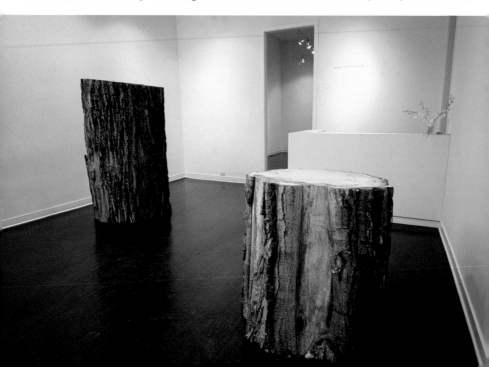

scends the depredation of the environment. He is also concerned with the social consequences of intervention in the eco-system and their relationship to financial and symbolical values. Y. D.

◄ 01 / 03 02

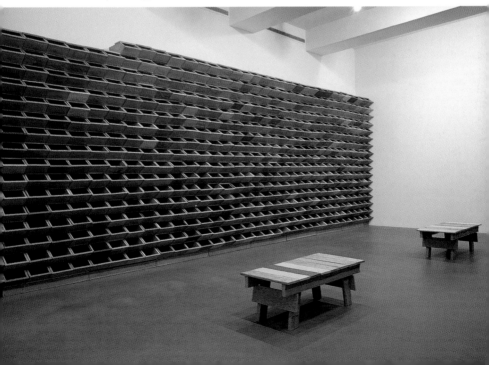

RAYMOND PETTIBON

1957 born in Tucson (AZ) / lives and works in Hermosa Beach (CA), USA

"I have never really thought of the possibility of people looking at my work expecting to find some ultimate meaning, because it's not what the intention is."

Raymond Pettibon's illustrative ink drawings, videos, books and wall paintings are all presentations of a complex mentality and relation to reality. Neither the extensive ramifications of Pettibon's countless drawings nor the relationship between elements of text and picture within the individual works lend themselves to an unambiguously logical consideration. They are pinned to the wall close to one another and above one another, so that their presentation underlines the impression of fundamental inconclusiveness. Pettibon idiosyncratically combines quotations from writers like Henry James or Marcel Proust or of his own with themes from everyday life on the American west coast, politics, the media, comics, film, the world of art and the hippie and punk movements of the late 1960s and 70s. It is a fragmentary, freely associative and sometimes contradictory interpretation of reality. In particular, the videos of 1988/89, "Weathermen", "The Book of Manson", "Sir Drone" and "Citizen Tania", make pointed comments on the political concerns and conflicts of sub-culture movements. According to them, the utopias of the 1960s ended in violence, as in Charles Manson's serial killings. These themes and figures also recur in Pettibon's sharply contrasted black and white drawings. Like other subjects – surfers, electric light bulbs, trains, phalluses, clouds etc. – these allusions also serve as literary material for an obsessive treatment of reality. This includes drastic shifts of mood as well as black humour and a certain scepticism. For when a speech balloon in a drawing of 1991 announces the desire to integrate its "poor little fragmentary ism" in a more comprehensive pictorial language, this does not necessarily correspond to the artist's own intention. It is rather one of the many voices that find utterance in Pettibon's pictures. A. W.

01

02

01 NO TITLE (BASKING IN THE …), 1990. Ink on paper, 57 x 76 cm. **02 NO TITLE (EVEN THE MOON …),** 1992. Ink on paper, 56 x 43 cm. **03 NO TITLE,** 1987. Ink, mixed media on paper, 36 x 28 cm. **04 NO TITLE (TO DO WHAT),** 1995. Pen and ink on paper, 127 x 97 cm. **05 NO TITLE (O-GASM …),** 1994. Ink on paper, 64 x 49 cm. **06 NO TITLE,** 1990. Ink on paper, 20 x 13 cm. **07 NO TITLE,** 1992. Ink on paper, 22 x 29 cm. **08 NO TITLE (WHAT CROPPED UP),** 1991. Pen and ink on paper, 39 x 29 cm.

03

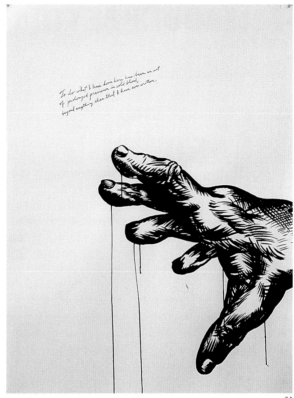

04

05

06

07

08

ELIZABETH PEYTON

1965 born in Danbury (CT) / lives and works in New York (NY), USA

"I always paint for myself."

In her drawings, watercolours and oil paintings Elizabeth Peyton combines aspects of popular culture with those of classical portraiture. On this point, she once stated that music magazines are just as important for understanding her work as, for instance, the writings of Marcel Proust. Her subjects have included pop singers, friends and acquaintances, and also historical personalities such as Napoleon Bonaparte or Ludwig II of Bavaria. Irrespective of the actual relationship between artist and model, all her portraits imply a high degree of intimacy. Her friends are represented in similarly introverted, often melancholy moods, as are the elegiacally portrayed figures of the pop world or certain protagonists from world history known for their eccentric behaviour. Peyton's sitters often have the aura of cult figures. This applies to the pictures of Kurt Cobain, who died in a tragic suicide, and also to those of Jarvis Cocker, the singer with the English group Pulp, and the Punk Rocker Sid Vicious. As a rule, Peyton confines herself to small formats. She adds further emphasis to the private nature of her pictures by giving most of them only the subject's first name as a title. Peyton stylises the members of the British royal family in the same androgynous and glamorous manner as the singers and actors she paints. Her traceable brush strokes and running patches of transparent paint suggest an intuitive technique, reinforcing the impression of immediacy and emotionality. She thus manages to provide her public personalities with the appearance of private persons, and to create the intimate, sensitive atmosphere that is so characteristic of her pictures. Y. D.

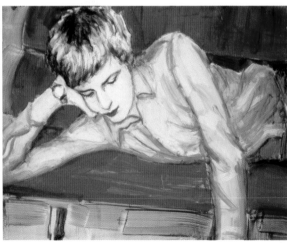

01

02

03

01 PIOTR ON COUCH, 1997. Oil on board, 23 x 31 cm. **02 CRAIG,** 1997. Watercolour
on paper, 26 x 18 cm. **03 JAKE CHAPMAN,** 1995. Oil on masonite, 43 x 36 cm.

STEVEN PIPPIN

1960 born in Redhill, England / lives and works in London, England, and Berlin, Germany

"I have become fascinated with the idea of constructing ... an instrument designed with the intention of recording its own mechanism and features."

Steven Pippin is the nostalgic melancholic of media art. By avoiding state-of-the-art technology in his objects and installations, he succeeds in recalling for a brief moment those sentimental hopes that were once placed in photography and television. The fundamental, fascinating processes of media technology can be re-experienced in this technical reduction, while a melancholy wink announces the profanity of their actual application. For instance, a late-nineteenth-century aura pervades "Wardrobe Obscura", 1986, for which the artist converted a wooden bathing-cabin, like those found in English seaside resorts, into a camera. There are no intimate pictures on view, as might be expected of a changing-cabin transformed into a photo kiosk. The photos that are exposed and developed here are blurred and apparently covered with a patina. In their poetic lack of focus, they refer back to the medium's birth pangs. Subsequently, this DIY enthusiast and puzzle-freak converted washing-machines, toilets and even a house into cameras. The result is a tautology – photo technology that reproduces only the process of photographing. In later works Pippin examines the media world from the point of view of its reception. The "Geo-Centric T. V." of 1998 consists of a rocket-like stand on which a monitor revolves on two axes; a globe is visible on the screen. Instead of moving pictures consumed worldwide by passive viewers in front of a stationary TV set, the artist has constructed a moving television set with a stationary picture of the world; perhaps Pippin is suggesting that a reversed view of the world is the only true version. R. S.

01 LAUNDROMAT-LOCOMOTION (RUNNING NAKED), 1997. B/w contact prints made from original paper negatives, 12 parts, 81 x 81 cm (each). **02 FLAT FIELD**, 1993. Aluminium, motors, transformers, perspex, television, video transmitter, video player, 122 x 94 x 119 cm.

STEPHEN PRINA

1954 born in Galesburg (IL) / lives and works in Los Angeles (CA), USA

"The meaning of an artwork cannot be reduced to the ideas that generate it."

Stephen Prina's pictures, installations and musical or other performances often take as their starting point "irrevocable representations", that is, well-known artistic and musical works. The various levels of meaning in his works are often revealed only through a sequence of historical references and influences. For instance, the proportions of Prina's monochrome drawings in "Exquisite Corpse: The Complete Paintings of Manet" (from 1988 on) correspond to the measurements of Edouard Manet's total of 556 paintings. Again, in "Monochrome Painting" (1988/89) the formats of his pictures in green car paint and their subtitles are derived from modern paintings, including Kasimir Malevich's "White on White" of 1919 or Blinky Palermo's "Untitled" of 1973. Prina's projects, which are often long-term, are concerned with the reception of cultural and art history, the mechanisms of the art business (e. g. "Mailing List", 1989/90) and the history of his own exhibitions ("Retrospection under Duress", 1996). Duplicating his

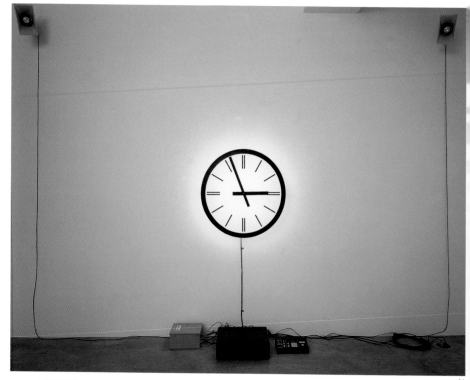

01 THE TOP THIRTEEN SINGLES FROM BILLBOARD'S HOT 100 SINGLES CHART FOR THE WEEK ENDING FEBRUARY 20, 1993, 1993.
The first in a series of 10 unique works, enamel on aluminium, acrylic, electrical hardware, ø of clockface 90 cm.
02 "THE BINATIONAL: AMERICAN ART OF THE LATE 80'S", installation view,
Kunstverein für die Rheinlande und Westfalen, Düsseldorf, Germany, 1988/89.

models' individual features, analysing their material data, and then reconstructing them, Prina examines the ritual of creating cultural value, and shakes its foundations – questioning issues such as originality, autonomy and authorship. In "Dom Hotel, Room 101", 1994, he takes up the monologue of a character in one of Heinrich Böll's novels and the novel's adaptation by the film-makers Jean-Marie Straub and Danièle Huillet. Here, too, the process of appropriation, emphasis and fade-out plays a central role. In this, Prina's sometimes ironically exaggerated analyses do not simply deliver a detailed record of his methodology: they introduce an arbitrary factor in his seemingly self-reflective systems, opening them up to other interpretations. A. W.

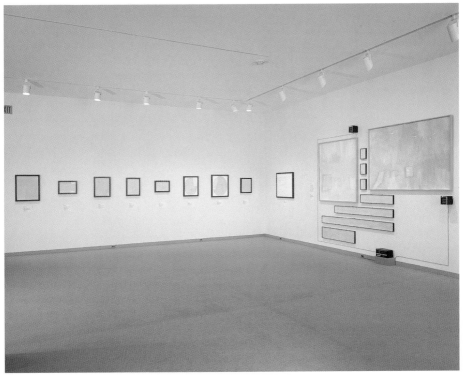

RICHARD PRINCE

1949 born in Panama Canal Zone / lives and works in New York (NY), USA

"I want the best copy. The only copy. The most expensive copy. I want James Joyce's 'Chamber Music'. […] I want the earliest copy on record. I want the copy that is rarer than anyone had previously dreamt of. I want the copy that dreams."

The principle of appropriation was originally developed by Marcel Duchamp at the beginning of the 20th century, reaching a climax in the 1960s with Pop Art. At the end of the 1970s it came back into fashion and, even more so than in Pop Art, pictures from advertising or television were adopted wholesale by artists for use in their own work. Richard Prince was one of the first, and one of the most provocative practitioners. At that time, he was working for the cuttings service of *Time Life* publications in New York, and therefore had access to thousands of magazines, in most of which only the advertisement pages remained intact. He began to photograph these advertisements, and then to compose his own pictures from the photos, finding that the detail, colour and angle of vision were changed if the camera was not held straight. For instance, in the series "Cowboys", 1980–1987, what at first seems to be an exact copy of a Marlboro advertisement is soon revealed – through such details as an intentional lack of focus, special emphasis on the figure, or its particular arrangement – as an artistic treatment. The synthetic, perfect world of advertising was not imitated but rather returned to imperfect reality. Pop Art's homage to advertising and consumerism was thus brought to an end. When Prince later produced large canvases displaying often coarse visual and written jokes, he was making an allusion to an ancillary aspect. The advertising world is a substitute world, and so is that of the joke. Both make similar use of clichés and wishes that cannot be fulfilled.

C. B.

01 UNTITLED (COWBOYS), 1980–1984. Ectacolour print, 69 x 102 cm.
02 UNTITLED (COWBOYS), 1980–1986. Ectacolour print, 69 x 102 cm.
03 UNTITLED (COWBOYS), 1980–1984. Ectacolour print, 69 x 102 cm.
04 UNTITLED (COWBOYS), 1980–1986. Ectacolour print, 76 x 114 cm.
05 UNTITLED, 1989. Acrylic, silkscreen on canvas, 229 x 147 cm.

01 / 02
03 / 04

"I understand your husband drowned and left you two million dollars. Can you imagine, two million dollars, and he couldn't even read or write."
"Yeah, she said, and he couldn't swim either."

CHARLES RAY

1953 born in Chicago (IL) / lives and works in Los Angeles (CA), USA

More than the work of practically any other artist, Charles Ray's figures provide stark evidence of the return of the real into art. He began working at the time when Minimal and Body Art were prevalent, presenting issues related to the body in abstract or performative pieces. When he started to make casts of his own body, and then introduced shop-window mannequins into his works, he brought a disturbing immediacy into sculpture whose effect was almost psychotic. His figures are distorted versions of humanity that at first seem familiar: the beautiful woman, the handsome male model, the unremarkable, average man in his forties – Ray himself. But these smooth, stereotyped mannequins are often too big or too small to be truthful representations. There is something oppressive in the monumentality of the megawoman who emasculates every man who approaches her, degrading him to the size of a child ("Fall", 1992), or in the four family members, all scaled to the same size so that the parents are proportionately tiny while the children are blown up into monsters ("Family Romance", 1993). Ray's traumatic realism also embraces everyday items – the "minimalistic" cube, cutlery that revolves on a table ("How a Table Works", 1986), or an ambulance as a sculptural object ("Unpainted Sculpture", 1997). With these nightmarish allegories he activates contemporary associations and social references. The squashed car of 1997, for instance, makes us think of Lady Di's accident, while in 1992, numerous art critics interpreted

01 **FIRETRUCK,** 1993. Mixed media, 3 x 13.7 x 2.4 m. 02 **TUB WITH BLACK DYE,** 1986. Tub, glass test tubes, pipe, dye, 84 x 150 x 76 cm. 03 **OH! CHARLEY, CHARLEY, CHARLEY ...,** 1992. Mixed media, 183 x 457 x 457 cm.

the sex orgy "Oh! Charley, Charley, Charley ..." as a metaphor for the AIDS era. But Ray deals with more petty emotional and mental conditions – narcissism, the longing for love and beauty – which are re-evaluated in his more recent thematic works about fashion and models, including a video of a revolving mannequin or a photographic series on "the most beautiful woman in the world". S. T.

02

◄ 01 / 03

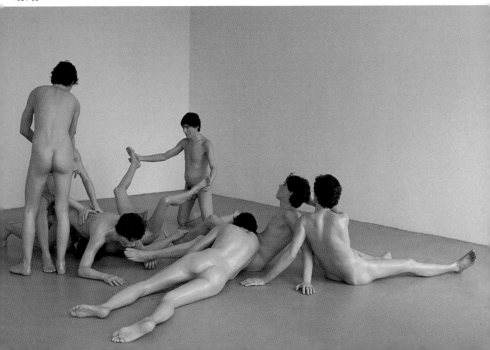

TOBIAS REHBERGER

1966 born in Esslingen/N., Germany / lives and works in Frankfurt/M., Germany

"Everyone sees art differently. I only make suggestions."

A blue ashtray and two television sets within outsize "tennis balls" hang above a pair of yellow armchairs. This arrangement, entitled "No Need to Fight about the Channel. Together. Leant Back", is part of Tobias Rehberger's installation "Fragments of Their Pleasant Spaces (In My Fashionable Version)", 1996. This is what resulted when the artist asked his friends to come up with ideas for the ultimate in comfortable interior design. Rehberger then translated the answers into his own "fashionable" interpretations. The work exemplifies his key strategies: collaboration, a working method related to space, and a questioning of the limits of art, fashion and design. Clichés and expectations are also playfully queried. In 1997 he designed an advertisement for a Berlin gallery, which appeared in art magazines. He then presented the advertisement to a knitter, who used it as a pattern for garments worn by gallery staff during an art fair. Subsequently, the gallery used the advertisement as a model for the exhibition "Brancusi". The

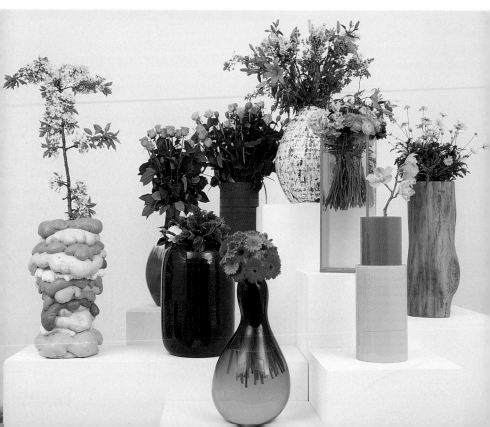

two-dimensional layout was translated spatially on to three-dimensional surfaces. These could be read as 1970s-style furniture or as autonomous sculptures. In this "three-piece", Rehberger renounces his authorship, concentrating like a manager on co-ordinating different processes and thus reducing hierarchies, including those between artist and mediators. Also characteristic is the way in which he introduces unfamiliar relationships to ensure that his collaborators have their own freedom of interpretation: an advertisement is just as unsuitable for a knitting pattern as it is for the plan of an exhibition. R. S.

◄ 01 / 02

01 **"ONE"**, installation view, neugerriemschneider, Berlin, Germany, 1995.
02 **BRANCUSI.** Wallpainting, 5 seats, 3 lamps, wooden floor, 11 original works by sundry artists.
Installation view, neugerriemschneider, Berlin, 1997.

JASON RHOADES

1965 born in Newcastle (CA) / lives and works in Los Angeles (CA), USA

"All good thoughts and all good works of art run on their own as a perpetual motion machine, mentally and sometimes physically; they are very alive."

Jason Rhoades creates large artworks, often spread out on the floor in many parts and occupying whole rooms. Lights flash, music plays and sometimes a video runs on a tiny television. Rhoades is blessed with the skill of the tinkerer, constructing machines that make chips, manufacture doughnuts, scatter, emit smoke or simply produce a noise. This jolly yet serious artist from Los Angeles has made an important contribution to the redirection of art world attention in the late 1990s from New York to the American west coast. Rhoades's creations set up systems of relationships between reality, experience and the media. The viewer browses through a network of objects and contemplates the associations arising from them. In "Uno momento/the theatre in my dick/a look to the physical/ephemeral", 1996, Rhoades uses

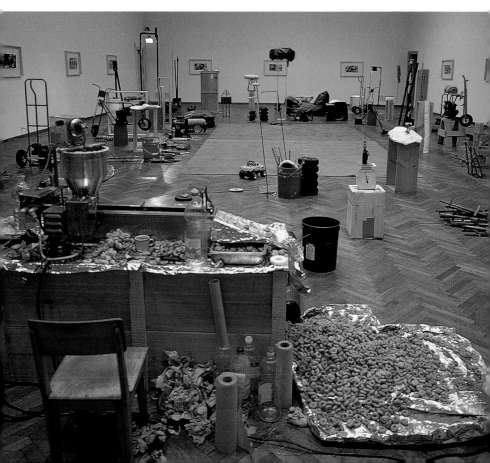

01 MY BROTHER/BRANCUZI, 1995. Carpet, wood, steel, doughnut machine, doughnut mix, small gasoline engines, various tools, plastic, drill, whisk, etc., 183 x 366 x 732 cm. Installation view, Epicenter Ljubljana, Moderna Galerija, Ljubljana, Slovenia, 1997.
02 UNO MOMENTO/THE THEATRE IN MY DICK/A LOOK TO THE PHYSICAL/EPHEMERAL, 1996. Various materials. Installation view, Kunsthalle Basel, Basle, Switzerland, 1996.

the basic motif of the 1970s film "Car Wash", picking up and expanding its colour and architectural elements to make the car wash a giant phallus shape nearly twenty metres long. But even those who do not immediately recognise the connections will feel the continuous and harmonious inducement to look around them. Rhoades reacts to the thousands of impressions that we all receive every day. His works create in the viewer the same compulsiveness or indifference as the temporary offerings of daily media and happening culture, which one can either share or reject. Rhoades repeatedly turns this process into art. C. B.

◄ 01 / 02

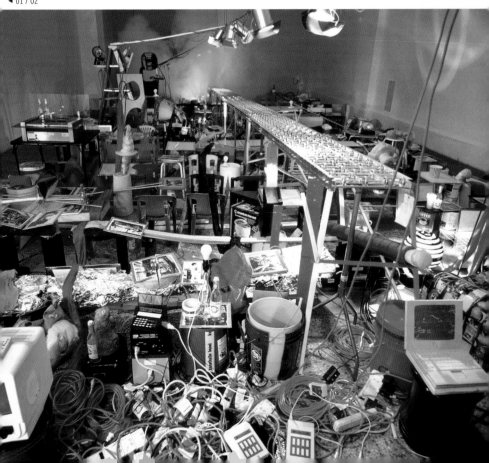

PIPILOTTI RIST

1962 in Grabs, Switzerland / lives and works in Zurich and Neuenburg, Switzerland

"Messages that are conveyed emotionally and sensuously can break up more prejudices and habitual behaviour patterns than umpteen pamphlets and intellectual treatises."

The work of video artist Pipilotti Rist is flashy, colourful, cheeky and self-confident. As a result, she swiftly conquered the art world, proving that it is possible to rival the mass of music videos with work on a higher plane. Having played in a band for years, she understands the aesthetics of pop culture, and seems to have noticed that this element was rather under-represented in the art of the early 1990s. At first, her strident videos were somewhat off-putting, seeming banal, stagey and whimsical. She often included herself in the work, but this by no means dominated the content. Rist spoke once of the "raging class war between the literate and those brought up on pictures (e. g. through TV)". How she saw the former was evident in her installation "Das Zimmer" (The Room), 1994. Huge red armchairs were grouped round a small television set, occupied by adults goggling at the videos on the screen, wide-eyed like young children. The public was thus presented with its own inadequacy, but so subtly that it did not even notice. Thematically, Rist depicts in increasingly large-scale video projections the daily madness of unsolved problems, though without lapsing into despair. In "Ever is Over All", 1997, a young woman runs down the street cheerfully smashing the windscreens of parked cars. A second projection alongside shows flower-filled meadows. A policewoman turns up and warmly greets the hooligan. Rist thus presents new alliances in her work that could hardly be conveyed through text, but can easily be read as pictures. C. B.

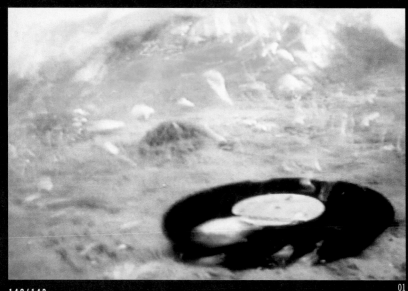

01

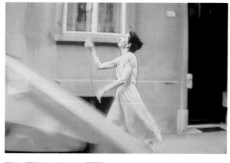
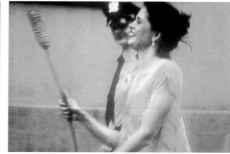
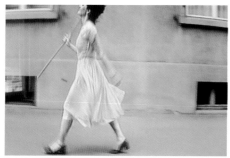

01 SIP MY OCEAN, 1996. Video still. 02 EVER IS OVER ALL, 1997. Video stills.
03 SELBSTLOS IM LAVABAD (SELFLESS IN THE BATH OF LAVA), 1994. Video still.

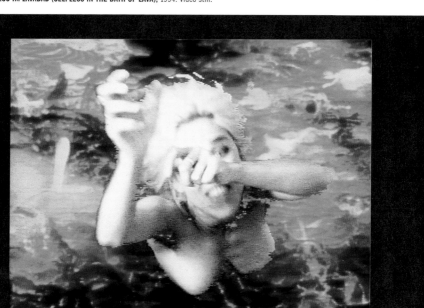

GERWALD ROCKENSCHAUB

1952 born in Linz, Austria / lives and works in Berlin, Germany

"My concern is with the definition and structuring of a social playing field that shows actions through their execution."

At the centre of Gerwald Rockenschaub's artistic methodology stands the "White Cube" as the setting, essence and premise of modern art. Rockenschaub became known in the early 1980s with his geometrically abstract pictures reminiscent of pictograms. Towards the end of the 1980s, he began to express his reflections on the status and social place of art in three-dimensional form. Adopting the idiom of Minimal Art, his artistic endeavours aim to examine and restructure the visual focus and behavioural norms defined by the context of each work. Rockenschaub uses laconic allusions to the architecture of the exhibition space to create a dynamic relationship between artist, work and viewer. He steers the attention to the parameters of presentation, transforming the art institution into a kind of backdrop setting. The beholder becomes an actor, and like the exhibition space, an object viewable by other visitors. In 1989, Rockenschaub clad a wall of the Paul Maenz Gallery in Cologne with transparent plexiglass panels. Two years later he divided two exhibition rooms in the Lucerne art museum with a transparent synthetic sheet. In the Metropol Gallery he did this with a cord, and he guided visitors to the Austrian pavilion in Venice (1993) across a construction like a gangplank. As in his earlier projects, the attention

02

of visitors was steered through the windows to the outside. In Zurich (1994) and Linz (1995), Rocken-schaub returned to this dialogue between the art interior and the urban exterior. He showed photographs of Zurich and also a video that explored first the administration wings of the museum and then the city centre of Linz. As with the events at which Rockenschaub appears as a DJ, there is here a merging of areas that are socially different. Their boundaries become visible but also open. A. W.

01 **INSTALLATION VIEW,** XLV Esposizione Internationale d'Arte, la Biennale di Venezia, Venice, Italy, 1993.
02 1997. 3 digital prints, 55 x 90 cm, 55 x 45 cm, 55 x 90 cm. **03 3 INFLATABLE PVC OBJECTS,** 1997.
2 inflatable walls, PVC, c. 220 x 450 x 35 cm (each); inflatable sofa, PVC, 50 cm (h), ø 200 cm. Installation view, Galerie Mehdi Chouakri, Berlin, Germany, 1997.

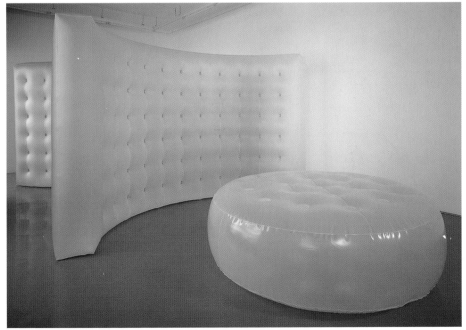

THOMAS RUFF

1958 born in Zell am Harmersbach, Germany / lives and works in Düsseldorf, Germany

"The difficulty with the portrait is to represent the smile."

Thomas Ruff – like Candida Höfer, Andreas Gursky and Thomas Struth – is pigeonholed to the tradition of Bernd and Hilla Becher's objective documentary photography. At first sight Ruff's various series – "Porträts" (Portraits), "Häuser" (Houses), "Zeitungsfotos" (Newspaper Photographs) and "Sterne" (Stars) – seem to fulfil the expectations of a sober recording of reality. But he is not so much concerned with copying and storing what exists as with realizing pictures from the world of his imagination, which follow strict, self-imposed rules of composition. So we find that his portrait subjects look straight into the camera as in a passport photo, or like his "houses" are isolated from their architectural surroundings. Ruff's pictures are imbued with a fundamental scepticism as to the conceptions of truth and authenticity or any idea that they should use photography as "proof". The fact is that the technical apparatus has a decisive influence on form. By changing the parameters and employing some computer manipulation, he shows that each visual apparatus creates the reality that it claims to reveal. In this sense, his works are "documents of disbelief" (Ruff). They reflect the conditions of perception, the peculiarities of the photographic medium and the (implicit) political dimension of its use. For instance, the night pictures made during the Gulf War had a bearing on the use of military recording technology for wartime reporting – a synonym for the voyeurism of the western television viewer. A more recent group of works, "Plakate" (Posters), from 1997, make this political dimension clear. In large-scale computer montages in the style of John Heartfield, he treats the self-satisfied attitudes of contemporary politicians with reductive irony, though the multi-levelled composition resists an unambiguous interpretation. A. W.

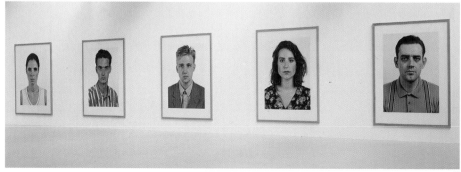

01

01 **"YOUNG GERMAN ARTISTS 2",** installation view, Saatchi Gallery, London, England, 1997.
02 PLAKAT IV, 1997. C-print, 225 x 180 cm.

GREGOR SCHNEIDER

1969 born in Rheydt / lives and works in Rheydt, Germany

"The brain cuts out and the body goes on turning until it tears."

Sixteen years ago Gregor Schneider, now 32 years old, began to convert his house in Rheydt, on the lower Rhine. Since then, he has gone on with his principal work, this "ur" house in Unterheydner Strasse. He builds walls in front of existing walls which often look identical to those behind them. Frequently he puts sound-insulating materials such as sheets of lead behind the walls, which he then plasters. The result is that the rooms become smaller with each layer and their proportions alter. One physically senses the effect of an increasingly oppressive atmosphere, without at first being able to make out what has caused it. As a result of all this conversion work, Schneider can no longer reconstruct the original layout of the house. One room in the house has been revolving with imperceptible slowness on its own axis. Others may have several windows arranged behind one another, with lamps placed between the panes of glass to simulate natural light. After finishing the architectural alterations, Schneider makes photos and videos of his house. He films the interior rooms in long, motionless takes, or stumbles through the house with a hand-held camera, providing

glimpses of otherwise hidden nooks and crannies. When he first began exhibiting, Schneider reconstructed the rooms of the gallery like the rooms of his house, but the conversion was not clearly visible in the end. Since 1994, therefore, he has been dismantling whole rooms from his house stone by stone and rebuilding them in museums and galleries. In this way he manages to transfer the atmosphere specific to his house into an exhibition context. Y. D.

01 TOTES HAUS UR, RHEYDT 1985–1997. 02 PORTRÄT GREGOR SCHNEIDER, U7 – 10, KÜCHE, RHEYDT 1987.
Installation view, "Schneider Totes Haus ur 1985/97, Rheydt", Portikus, Frankfurt/M., Germany, 1997.
03 UR 10, DREHENDES KAFFEE-ZIMMER, WIR SITZEN, TRINKEN KAFFEE UND SCHAUEN EINFACH AUS DEM FENSTER, RHEYDT 1993.

CINDY SHERMAN

1954 born in Glen Ridge (NJ) / lives and works in New York (NY), USA

"Even though I've never thought of my work as feminist or as a political statement,
certainly everything in it was drawn from my observations as a woman in this culture."

Cindy Sherman once stated that her photographs are to be understood as Conceptual Art. This conceptual approach is particularly apparent in the division of her work into series. For all their variety, these reveal some constant themes such as her preoccupation with painting, which she investigates using photographic means, or the social image of women. The first photos with which Sherman shot to fame in the early 1980s were her "Film Stills". These black and white self-portraits show the artist in different situations which are reminiscent, in both technique and content, of stills from 1950s and 60s films. Subsequently, Sherman turned exclusively to colour photos. One significant series was made at the request of the New York art periodical "Artforum". The pictures are double-page spreads – a wide landscape format matching that of the magazine – often showing the artist lying down with a fixed expression on her face. Around 1983 Sherman took her first fashion photos, in which she caricatures the accepted ideal of feminine beauty. In the course of her career, from "Fairy Tales", 1985, to "Disasters" (1986 onwards), Sherman has increasingly alienated her self-portrait. The artificial body parts that she had already used in the "History Portraits", 1988–1990, assume the role of protagonists of the representations in "Sex Pictures", 1992. As with the later "Horror Pictures" (1994 onwards), the artist's body completely vanishes from the pictures, only appearing again in person from time to time in some of the more recent "Mask Pictures" (1995 onwards). In her most ambitious project to date, the horror film "Office Killer", 1997, Sherman links her concern over the social position of women with aspects of film history.

Y. D.

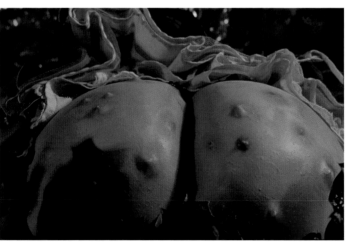

01 UNTITLED, 1987. Colour
photograph, 110 x 186 cm.
02 UNTITLED, 1992. Colour
photograph, 152 x 102 cm.

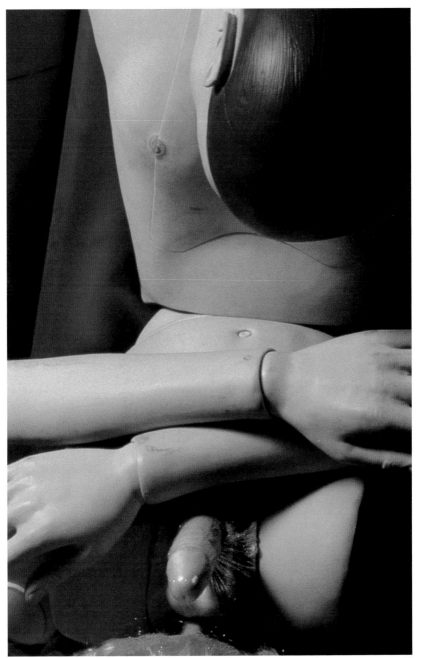

ANDREAS SLOMINSKI

1959 born in Meppen, Germany / lives and works in Hamburg, Germany

"Andreas Slominski would like the following two pages not to be touched."

Andreas Slominski is a hoaxer and a setter of traps. Just when one has been taken in by his aesthetic offerings, they turn out to be tricks. It is for instance impossible for the reader of this book not to touch the following two pages, because he has to turn them over before he can carry on reading. Slominski became known through his traps. He places actual animal traps in the exhibition room as readymades that really work and are set to spring, representing a real danger for the viewer. The artwork as a trap can here be seen in concrete form, but it can also be understood on a symbolic level. For if we want to interpret a work of art, we have to enter its sensory and conceptual world, but in doing so we get truly caught. If however we, so to say, remain outside it, we have the chance of being unharmed and enjoying the work's mere appearance. The traps are therefore simultaneously ordinary practical objects, conceptual art and autonomous sculptures. Another working principle of Andreas Slominski can be paraphrased with the formula "much ado about nothing". In his "Golfball-Aktion" of 1995, for example, he simply displayed a normal commercial golf ball in the Museum Haus Esters in Krefeld. Then he got a local golfer to hit this ball over the roof of the museum. The ball landed on a specially parked lorry that was invisible to the golfer, and then rolled from the lorry's tipped-up loading surface, through a previously widened window, back to its destined place in the exhibition room. Economic principles such as efficiency and optimal methodology are, as so often in Andreas Slominski's work, carried to the point of absurdity with a lovingly planned but at the same time apparently fortuitous attention to detail. R. S.

05

01 / 02 / 03 / 04 **UNTITLED,** 1995. Andreas Slominski had a golfer strike golfballs over the roof of Museum Haus Esters
until one hit the tilted ramp of a lorry parked behind the house and bounced through an open window into the museum.
05 **ANFEUCHTEN EINER BRIEFMARKE/LICKING A STAMP,** 1996. Event in zoo with giraffe and zoo-keeper on June, 27th.
Skulptur. Projekte in Münster 1997, Münster, Germany, 1997.

03

04

THOMAS STRUTH

1954 born in Geldern, Germany / lives and works in Düsseldorf, Germany

Recently, what has interested me is, how can I record ecstasy ... !
or: 'quietness' in a picture."

"Unknown Places" was the title Thomas Struth gave to a large touring exhibition of his photographs in 1987. The name is appropriate, for Struth's towns are anonymous: sites that are decidedly urban, but which would hardly stick in the viewer's memory as individual images. His style, on the other hand, is always recognisable. Usually photographed in black and white from a central perspective, these near-empty towns show a host of details but no real focal point. The viewer feels somewhat disorientated, trying to give the place a meaning, to extract its secret. And every town, every corner of every town, possesses many secrets, as Struth has documented since his early works. The wealth of detail is continued in the later photos taken in China and Japan. Now people are present. But they do not draw attention to themselves, becoming merely additional details in the midst of a mass of advertising messages. In a further series, Struth photographed groups of people in museums. The pictures they are looking at also depict human figures, so that there is a great deal of gazing in both directions, from the pictures and into the pictures. In his latest video works, which were produced with Klaus vom Bruch, Struth still remains true to style. The camera stands statically at a certain point, but the eye is not really offered a fixed focus and there is a great deal to see. Struth points out things that we do not normally find remarkable. His theme is the ordinary day, the public space, presented so subtly that no information gets lost. C. B.

01

01 LANDSCHAFT NO. 23, WINTERTHUR 1992. C-print, 118 x 137 cm (framed). 02 WANGFUJING DONG LU, SHANGHAI 1997.
C-Print, 84 x 112 cm (framed). 03 CHIESA DEI FRARI, VENICE 1995. C-print, 235 x 187 cm (framed).

SAM TAYLOR-WOOD

1967 born in London / lives and works in London, England

"I am interested in how things are offered to us, what situation people are put in who are asked to be entertained."

In Sam Taylor-Wood's videos and photo-panoramas there is a prevailing suspense, like the tension in a film. She puts people together and fixes a situation – in videos a scene, in photos a frozen moment. Human relations hover between fascination and destruction, represented with a remarkably intense expression of individualisation, which makes each act seem isolated. The salient force in Taylor-Wood's works is the application of a technique which rebounds from the content back on to the viewer and thence on to the psychology of perception. Her "Travesty of a Mockery" of 1995 is a ten-minute quarrel scene between a man and a woman (played by an amateur and a professional actress) in which the characters are separated from one another by two projections on two different walls. In "Atlantic", 1997, another drama of relationships, one finds oneself between three perspectives, which simultaneously show a distraught and desperate woman, a man's nervous hands, and a full restaurant surrounding them. Neurosis and psychosis are Taylor-Wood's idea of the present state of mind. She releases moments from these extremes and makes them advance on us like signals. Her own portrait came at the beginning of her work, and in this she showed a state of hurt through her own nakedness. Her recent works are a "film" composed of countless situations with different individuals. She transfers it photographically on to her stage-like 180-degree panoramas ("Five Revolutionary Seconds", 1995–1997). An all-round view like this of parallel stories can be uncommonly disturbing. S. T.

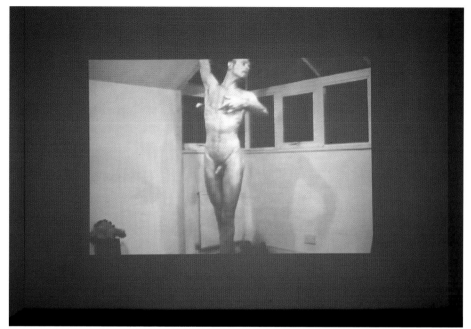

01 FIVE REVOLUTIONARY SECONDS X, 1997. Unique colour photograph on vinyl with sound, 107 x 500 cm.
02 FIVE REVOLUTIONARY SECONDS V, 1996. Colour photograph on vinyl with sound, 72 x 757 cm.
03 BRONTOSAURUS, 1995. Video projection and sound, 10 mins. Installation view, Kunsthalle Zürich, Zurich, Switzerland, 1997.

01

02

DIANA THATER

1962 born in San Francisco (CA) / lives and works in Los Angeles (CA), USA

"My work is specifically about being big, colorful and engaging, but it's about not being spectacular. It doesn't look spectacular."

Until a few years ago, video art was imprisoned in the little box of the monitor. Since the early 1990s, it has come to occupy the whole room courtesy of large video projections. Diana Thater consistently exploits this advance, and yet she deliberately ignores the possibilities of technical perfection. Her pictures run over jutting parts of walls, sometimes overlapping by a few centimetres; they are seldom projected at exactly the right angle, their colour appears to be wrong, and several images look as if they have been projected on top of each other. But what might seem like amateur mistakes actually represent a detailed examination of the video medium. The colour tinges pick out the colours from which the picture is composed, the unpretentious presentation corresponds to the uncomplicated possibilities of this accessible form, and the overlapping is the result of sophisticated electronic image mixing. However, these formal aspects can never dominate, for Thater is also highly concerned with content. She works with animals – a parrot, a monkey, two wolves and a herd of horses – especially trained for film takes. But instead of getting them to perform Hollywood-style tricks, she positions them in relation to the viewer. Within these works, we don't know whether the she-wolf is standing in front of us or behind us; whether the herd of horses is stamping about above or below us. Some of these works have narrative texts, but pervading all of them is the fundamental question: who dominates whom? Do the human beings control the animals, or the other way round? Do the media dominate humans or vice versa? C. B.

01 CHINA (BLUE AND YELLOW WALL VIEW), 1995. Installation view, "China", The Renaissance Society at the University of Chicago, Chicago (IL), USA, 1995. **02 BROKEN CIRCLE,** 1997. 6 video projectors, 1 video monitor, 6 laserdisc players, 1 sync generator, 6 laserdiscs, window film, and existing architecture. Interior view: Buddenturm, Floor #2 (view B), Skulptur. Projekte in Münster 1997, Münster, Germany, 1997.

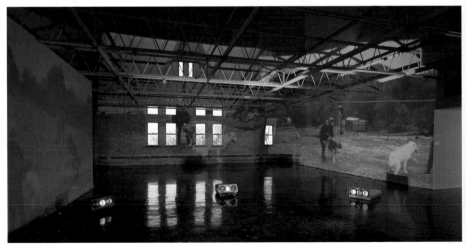

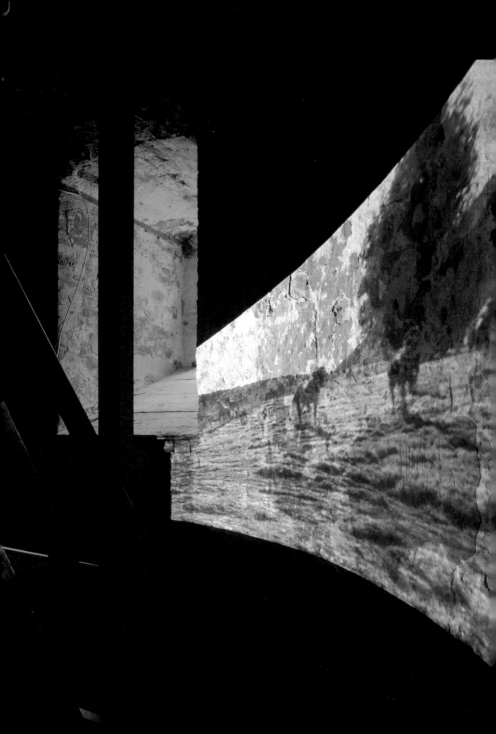

WOLFGANG TILLMANS

1968 born in Remscheid, Germany / lives and works in London, England

"I see myself as a political artist. I want to make a picture of my idea of beauty and the world I want to live in."

Wolfgang Tillmans, Turner Prize winner in 2000, became known in the early 1990s for his photographs of young people taken in their social environment – clubs, the Love Parade in Berlin, the European Gay Pride days in London or the Protestant Convention in Munich. He is often regarded as a documenter of his own generation. But the artistic composition of the photographs and their sometimes enigmatic content contradict an entirely documentary intention. For all the selfstylization of the young people he photographs, aspects of their personality keep shining through. Often the works also reflect the ambiguity of codes such as those of clothing, preventing consignment to a particular social classification. Alongside his portraits, Tillmans has concerned himself with subjects such as architecture and still life. From 1991 he made a comprehensive series on the arrangement of folds, in which, aside from the formal qualities (draping and colour composition), the items of clothing reveal a narrative potential. In his comprehensive series on the supersonic aircraft Concorde, 1997, he portrays the techno-mythology by reflection and atmosphere. Tillmans started early on using lifestyle and music magazines like "ID", "Interview" or "Spex" as a forum for his artistic work. In assessing his photos he makes no distinction between free work that he exhibits in the art context and commissioned work. In some exhibitions he shows works from both spheres – unframed photos stuck to the wall with sticky tape, like reproductions cut out of magazines. Y. D.

01

01 **STEDELIJK INSTALLATION 1988–1998,** 1998. Installation view, "From the Corner of the Eye", Stedelijk Museum, Amsterdam, The Netherlands, 1998. **02 STILL HOME,** 1996. C-print, 40 x 30 cm; 61 x 51 cm; bubblejet-print, 270 x 180 cm.

RIRKRIT TIRAVANIJA

1961 born in Buenos Aires, Argentina / lives and works in New York (NY), USA, and Berlin, Germany

"My work is about looking at the essential and what's essential to more than survival."

Rirkrit Tiravanija was born in Buenos Aires, brought up in Thailand and Canada, and currently lives in New York and Berlin. In his actions and installations he intentionally disrupts the traditional expectations of the passive exhibition visitor. In his first exhibitions, for instance, he placed the furniture and equipment from the gallery office in the exhibition room, where he also installed a temporary kitchen. Thai dishes were served, and over the meal Tiravanija chatted with visitors, as a pre-planned interaction between artist and viewer. Meanwhile, the normal business of the gallery went on, apparently undisturbed. Tiravanija designs rooms for communication and interaction. He turned the Cologne Kunstverein into a place of this kind by installing a wooden reconstruction of his New York apartment in the gallery, complete with functioning kitchen and bathroom. The Kunstverein was open day and night for the duration of the exhibition, and soon became an attractive meeting place, particularly for people who otherwise had little contact with art. In his other works, Tiravanija not only involves the public, but also presents structures in such a way that the actions of viewers comprise the artwork itself. He might install a set of drums in the gallery and ask visitors to make music, or he might rehearse a puppet play with young

01 UNTITLED, 1997 (THE ZOO SOCIETY). Installation view, Skulptur. Projekte in Münster 1997, Germany, 1997.
02 / 03 / 04 UNTITLED, 1994 (FROM BARAGAS TO PARACUELLOS DE GARAMA TO TORREJÓN DE ARDOZ TO SAN FERNANDO
OR COSLADA TO REINA SOFÍA). Mixed media, dimensions variable. Installation view, "Cocido y Crudo", Museo Nacional
Centro de Arte Reina Sofía, Madrid, Spain, 1994.

people. Tiravanija thus expounds his thesis – the origin of which may be traced to his cultural connection
with Thailand and Buddhism – that "it is not what you see that is important but what takes place between
people". Y. D.

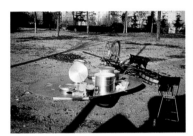
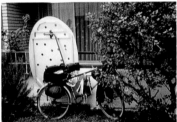

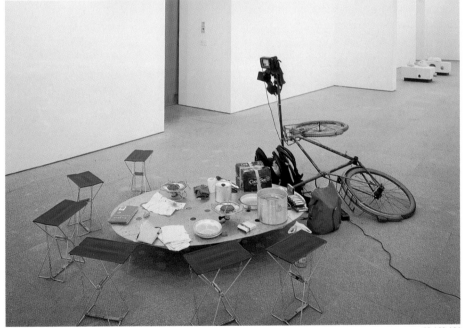

ROSEMARIE TROCKEL

1952 born in Schwerte, Germany / lives and works in Cologne, Germany

"Please don't do anything to me. Come on now."

The problems evoked in Rosemarie Trockel's work are at least as numerous and diverse as the materials and techniques she employs. In her videos, sculptures, installations, drawings and photographs she tackles, among other things, themes which occupied her during her studies of anthropology, sociology, theology and mathematics. Our relationship with the human body, the role of women in society and our attitude to our dealings with animals are only some of the aspects that repeatedly crop up in her works. There are for instance her representations of animals in the form of drawings and bronze casts, but also in the form of an installation with live animals, as in her joint contribution to documenta X together with Carsten Höller "Ein Haus für Schweine und Menschen" (A House for Pigs and People). The knitted pictures, with which Trockel first became known in the 1980s, and her cooker hotplate works, are not just comments on the female production of art but can also be interpreted as an examination of Pop Art and Minimal Art. When Trockel uses emblems like the Woolmark, the Playboy rabbit and even swastikas in her knitted pictures, she is in a subtle way querying the function of symbols and their meaning in relation to art. Thus her items of clothing knitted in wool, the terrorist balaclavas, the excessively long stockings and the strange pullovers are all artistic comments on the social meaning of fashion and its sometimes restrictive effects. Trockel's works that are reminiscent of readymades are in the tradition of Marcel Duchamp, like her display case objects with which she analyses – often with an ironic undertone – the inherent laws of the art world.

<div align="right">Y. D.</div>

01 LEBEN HEISST STRUMPFHOSEN STRICKEN, 1998. Photographs, postcards, goose eggs, 12 x 86 x 132 cm.
02 FAN 1, 1993. Scanner print on canvas, 150 x 150 cm.

LUC TUYMANS

1958 born in Mortsel, Belgium / lives and works in Antwerp, Belgium

"Pictures, if they are to have effect, must have the tremendous intensity of silence ...
the silence before the storm."

Content is central to Luc Tuymans' paintings. Reflection is more important for him than blatant sensuality. It is as "immaterial pictures", as Tuymans calls them, that these works acquire the power that pursues the viewer like an oppressiveness that will not go away. Although his paintings are often conceived as series, they continue to fascinate as individual pictures. Tuymans' relationship to painting is always conditioned by his experience with other media, especially film and photography. This influence finds expression in his use (and adaptation) of picture sequences from films, and in the way he deals with faded colours reminiscent of old photos. The Belgian's artistic themes range from Flemish history and American delusions of grandeur to the horror of German National Socialism. In his aesthetic enquiries, Tuymans acts not as a documenting outsider but as a participant, a fellow perpetrator. One's "own perversion" interests him, particularly when dealing with such extreme subjects as "Treblinka", 1986, or "Wiedergutmachung" (Reparation), 1987. "Wiedergutmachung" shows a row of children's limbs that had been found in the desk drawer of a former concentration-camp doctor. Tuymans neatly cut out photos of these limbs and accurately stuck them on a sheet of paper – mimetic recreation as a vain attempt at understanding. The painting "The Heritage II" of 1995 shows the US flag as a play of light disappearing into itself. This emblem of pointlessness bears witness to the fading of the American dream – and also of the failure of painting. "Every art has failed. How we fail is another matter," Tuymans confesses. R. S.

01 **SCHWARZHEIDE,** 1986.
Oil on canvas, 60 x 70 cm.
02 **DER DIAGNOSTISCHE BLICK IV,** 1992.
Oil on canvas, 57 x 38 cm.

01

JEFF WALL

1946 born in Vancouver / lives and works in Vancouver, Canada

"The experience of the beautiful is always associated with hope and art, as Stendhal said, a promise of happiness, a 'promesse de bonheur'."

Jeff Wall seems to fulfil this promise of happiness. The large-format colour slides presented in light-boxes with which he made his name in the 1970s, seduce the viewer with their surface brilliance and perfection of composition. And yet their "beauty" proves fragile. Gradually, disruptive factors appear on the scene – references to overt or latent violence, as in "Mimic", 1982, or grotesque details, as in "Dead Troops Talk", 1991/92. Wall sees himself, following Charles Baudelaire, as a "painter of modern life". He draws on the methods and pictorial resources of photography, film and (pre-)modern art in order to follow the "The Crooked Path", 1991, of genre, landscape, portrait and historical painting and paint his fictions of modern, mostly urban life. Nothing is left to chance: in the studio, Wall uses actors to stage tableaux full of art historical references, which he then partially synthesises on a computer. Here, he relies particularly on pictorial concepts from the beginnings of Modernism, where the unity of a picture was no longer taken for granted – as in his allusion to Manet in "Woman and her Doctor", 1980/81, for example, or to Cézanne in "The Drain", 1989. The controllability of the composition corresponds to the sense of oppression that often accompanies Wall's representation of social relationships. And yet his protagonists are not bound by one particular form of behaviour or role. Like the worker in "Untangling", 1994, they are usually shown in a moment of hesitation or of enforced waiting before a decisive occurrence which,

01

01 DEAD TROOPS TALK (A VISION AFTER AN AMBUSH OF A RED ARMY PATROL, NEAR MOQOR, AFGHANISTAN, WINTER 1986), 1991/92.
Transparency in light box, 229 x 417 cm. **02 INSTALLATION VIEW,** Art Tower Mito, Mito, Japan, 1997. **03 A SUDDEN GUST OF WIND
(AFTER HOKUSAI),** 1993. Transparency in light box, 229 x 337 cm.

like the wind in "A Sudden Gust of Wind (after
Hokusai)", 1993, can give an unexpected twist
to events. Subsequent developments are nor-
mally left unresolved. Wall's more recent
series of black and white photographs also
follow this principle of suggestion. The stories
that go with the pictures spring from the view-
er's imagination, guided by Wall's transform-
ation of our collective pictorial archive. A. W.

02

03

GILLIAN WEARING

1963 born in Birmingham / lives and works in London, England

"I'm always trying to find ways of discovering things about people, and in the process discover more about myself."

An important source of inspiration for Gillian Wearing came from the English TV serial "Family", a fly-on-the-wall-documentary in which a "real" family acted itself. According to Wearing, an incredible process of exposure took place in this series: "... the Wilkins family seemed so naive in front of the camera, and once they appeared on the screen the commonest situations suddenly became terrifying – their whole life was displayed." In Wearing's work this disclosure is repeated afresh: complete strangers reveal their dreams and innermost longings and thus surrender themselves to a disturbing form of portraiture. At first, she used the simple tactic of interviewing her subjects, posing certain questions and making series of works from the answers. In 1992/93 she asked passers-by in London to write on placards the exact thought that was passing through their head and then photographed each person holding up their sign ("Signs that …"). Others replied to an advertisement in the paper and agreed to speak in front of Wearing's video-camera about their lives ("Confess all on video", 1994). Subsequently, her concepts became more complex. She creates tensions through the medium she employs that alienate the portraiture. A group picture of a police team thus becomes a numbingly long video, a prolonged photo ("Sixty Minutes, Silence", 1996). The video "Sasha and Mum", 1997, runs alternately forwards and backwards, so that the quarrel between mother and daughter becomes an endless battle of love and hatred. The dubbed montage "10 – 16", 1997, is also a complete allegory in which the voices of youngsters issue from the mouths of adults. The personal histories of the teenagers penetrate the grown-up faces, becoming fateful projections of past and future.

S. T.

02 / 03
04 / 05 ▶

01 SIXTY MINUTES, SILENCE, 1996. Video back projection, 1 hour, 38 x 33 cm.
02 / 03 / 04 / 05 SIGNS THAT SAY WHAT YOU WANT THEM TO SAY AND NOT SIGNS THAT SAY WHAT SOMEONE ELSE WANTS YOU TO SAY, 1992/93. C-type print mounted on aluminium, 40 x 30 cm (each).

01

FRANZ WEST

1947 born in Vienna / lives and works in Vienna, Austria

"Take a chair off the shelf, use it for its purpose and then put it back again."

Most of Franz West's works are intended to be actively experienced with the body. With his so-called "fitting-pieces" from the 1980s, he envisages the viewer's physical participation. These amorphous sculptures with rough, crusted surfaces are meant to be laid against the body. Their curious shapes compel one to adopt extraordinary postures. West documented many of these actions by means of videos or photos. In his emphasis on body involvement and performance West comes close to Viennese Actionism, but his characteristic irony eschews their heavy pathos. His metal chairs and couches, which are covered with fabric or carpet, are a logical development of the "fitting-pieces". His furniture sculptures are also meant to be used by the exhibition visitor. Among other things, he made striking seating arrangements for the sun roof of the New York Dia Art Foundation, the open-air cinema of documenta IX and the great hall at documenta X. With these he demonstrated his work's intermediate position between an autonomous work of art and an object of use. Or his couches may be interpreted as an allusion to Sigmund Freud, whose writings West has studied intensively. West has also cooperated with friends in writing texts in which he reflects the thoughts of theoreticians like Wittgenstein or the French philosophers Roland Barthes, Gilles Deleuze or Jacques Lacan. From time to time, artist friends help to produce West's works. This

01

enables him to defy the romantic myth of
the autonomous artistic genius, and to widen
his work with additional facets of content and
style. Y. D.

02

03

1956 born in Los Angeles / lives and works in Los Angeles (CA), USA

"Show me an angel and I will paint one."

How photographs influence our view of reality is a question that has preoccupied Christopher Williams since the early 1980s. Initially, he worked with material from photo archives of museums, libraries, magazines or agencies. Towards the end of the 1980s, he began to produce photographs that frequently refer to existing cultural images. Detailed captions indicate possible selection criteria, connections and genealogies. Thus the caption to "Bouquet, for Bas Jan Ader and Christopher D'Arcangelo", 1991, is to be understood not only as homage to these Conceptual artists. We are also told in the caption that the bouquet was arranged from plants of countries mentioned in an earlier work by Williams, namely "Brazil", 1989. In the nine-part exhibition series "For Example: Die Welt ist schön" from 1993–1997, Williams continues this game of references. The title itself alludes to the famous photo book by Albert Renger-Patzsch, "Die Welt ist schön" (The World is Beautiful) of 1928. As a representative of New Objectivity, Renger-

01 "VALENTINE" TYPEWRITER 1969, PLASTIC (ABS), DESIGN ETTORE SOTTSASS JUN., PERRY KING, MANUFACTURE, ING.
C. OLIVETTI & CO. SPA ITALY, H. 11.5 CM INV. NO. V 6,3 – 393, (NR.1–4), 1996. Dye Transfer Prints, 64 x 75 cm (framed).
02 BOUQUET, FOR BAS JAN ADER AND CHRISTOPHER D'ARCANGELO, 1991. C-print, 41 x 51 cm.

Patzsch tried to capture the "essence" of structures and phenomena of the visible world and to set them in order. Williams's objectively distanced photographs of animals, plants, industrial products, Modernist architecture and people pick up not only Renger-Patzsch's pictorial style but also something of his aesthetic approach, such as the isolated presentation of individual objects. But Williams introduces subtle elements of disruption into these apparently objective illustrations, which often evoke colonialist associations. There is a scarcely perceptible shift in the angle of vision and moment of exposure when Williams uses a second camera in photographing Japanese models at fashion shows or young printers in Dakar, Senegal. The result is an alienated and alienating view of things that shows any objective recording of the world to be an illusory venture.

A. W.

JANE & LOUISE WILSON

1967 born in Newcastle, England / live and work in London, England

„Most of the photographic work is deliberately unpeopled and is presented in as near as possible 1:1 scale. It is up to the viewer to adopt the acting role in the pictured scene."

Jane & Louise Wilson are two of the Young British Artists involved, above all, in the media reality of pop culture. The functioning mechanisms of film, TV, music and advertising, and their influence on the recipients, occupy the foreground of their aesthetic research. One particular focus is the role of women. The twins mainly use video for their art, but also bring in photography and three-dimensionally presented architectural objects. In the video "LSD" of 1994, the Wilsons let themselves be put into a trance by a hypnotist whose voice is heard off-stage. It is not the spectators but the two actors, or actresses, themselves who are being put under a spell, and the seductive power of mass-media suggestion comes under scrutiny. Jane & Louise Wilson examine typical scenes from horror and action films in "Crawl Space", 1994/95, and "Normapaths", 1995. In both works, the female body features as an object of hysterical male fantasy. The two sisters go on a tour-de-force of horror, wearing the cool, black PVC dress of the legendary crime story star Emma Peel. They seek to escape from their imprisonment in the codes of film genres, and also to express their own anxieties and longings. "Stasy City" of 1997 takes video as a means of control as its theme. It was made in, among other places, a disused headquarters of the state security police (Stasi) in the former German Democratic Republic (GDR). Once again we are taken on a journey through a geography of horror, but this time the subject is recent history, which really existed, and not film fiction. And yet Jane & Louise Wilson illustrate the problems in their own medium when they take their camera through the eerie Stasi building. Always being watched – this was true not only in the GDR, but also characterises the reality of the Postmodern network. R. S.

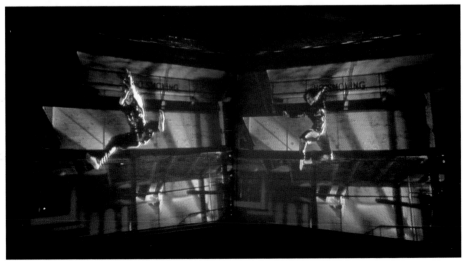

01 **NORMAPATHS,** 1995. Installation view, Chisenhale Gallery, London, England, 1995.
02 **DEN,** 1995. C-type print, 230 x 180 cm.

CHRISTOPHER WOOL

1955 born in Chicago (IL) / lives and works in New York (NY), USA

Christopher Wool adopts the 1950s and 60s style of all-over painting. Initially, he used a pouring technique that revived Jackson Pollock's dripping method in a mechanical and controlled way. Later, he employed repeating floral patterns that recall Andy Warhol's silkscreens. Finally he used stencil-like letters that are always appropriate to the format of the picture, which paradoxically – however stereotyped and anonymous they might be – became his signature. Wool's all-over painting is hard in appearance, and the aluminium support and the coldly glowing enamel paint, make his work seem far removed from the conventional idea of a painting. They have provoked many contradictory yet relevant interpretations. On the one hand, the letters form clear patterns, flattened to the status of ornaments and composed surfaces. They appear as definitive denials of pictures, finding their climax in linguistic concepts ("RIOT", "RUN", "DOG") and finally in chopped-up words ("THE SHOW I SOVER"). On the other hand, this cold refusal opens up through the uneven, proliferating print of the patterns or the dripping contour of the letters, whose inference is retained in spite of coding, such as "TRBL" (trouble). What was devoid of meaning becomes overloaded with it, both in terms of concept and in a decorative sense. For many years Wool's work achieved its effect through a reflective distancing, whereby street themes and thoughts on the end of painting were simultaneously embraced. But in the more recent, often manically thick, layered applications, calculated disruptions appear. Artistic gestures, pictorial subjects and common noun titles become the counterpart of rational cognition.

S. T.

01 UNTITLED, 1990.
Alkyd, acrylic on aluminium,
275 x 183 cm.
02 UNTITLED, 1990/91.
Enamel on aluminium,
274 x 183 cm.
03 UNTITLED, 1990.
Enamel on aluminium,
274 x 183 cm.

01

02

ANDREA ZITTEL

1965 born in Escondido (CA) / lives and works in Altadena (CA), USA

"I want to show people that it is possible to become your own expert, to try to create your own experiments and to understand the world in your own way."

Andrea Zittel's "A–Z Administrative Service" was founded at the beginning of the 1990s. It is presented as a service enterprise that introduces new products at regular intervals and offers them for sale and individual use. The objects Zittel creates are supposed to function and be useful in everyday living in contrast to the classical idea of a work of art. Moreover, her objects can scarcely be termed beautiful or even valued as designs. They arise from an artistic impulse which, to a certain extent, reacts to contemporary design, defines it anew and tries to improve it. Thus "A–Z Production" began with the "Living Unit", a completely functional dwelling unit reduced to 4 square metres, which initially organized the congestion of Zittel's own living conditions and then appeared in exhibitions in diverse variants as a product for sale ("A–Z Comfort Work", "A–Z Selected Sleeping Arrangements"). Zittel's puritanically practical designs, in which everything has a sensible function, recall the social utopias of the early avant-garde, especially their drive towards optimization and their promise of happiness. She speaks of a "tiny seed of perfection", which can impinge on present-day shoppers as a consciously selected experiment. In the meantime her scope has widened. In 1997 at documenta X Zittel showed spherical caravans that could be entirely appointed to suit individual taste as personal refuges ("Escape Vehicles"). In connection with "Skulptur. Projekte in

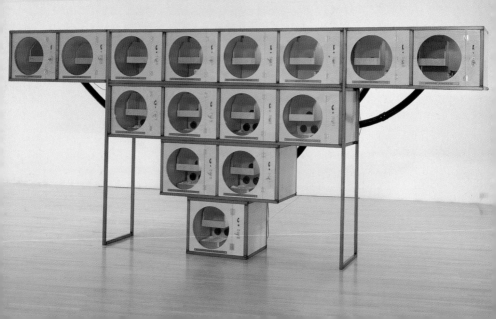

01 **A–Z BREEDING UNIT FOR AVERAGING EIGHT BREEDS,** 1993. Steel, wood, glass and electronics, 183 x 434 x 46 cm. 02 **A–Z DESERTED ISLANDS I–X,** 1997. 10 islands, fibreglass, wood, plastic, floatation tank, vinyl seat, vinyl logo, c. 91 x 229 x 229 cm (each). Outdoor installation view, Skulptur. Projekte in Münster 1997, Münster, Germany, 1997. 03 From left to right: **A–Z ESCAPE VEHICLE CUSTOMIZED BY ANDREA ZITTEL;** **A–Z ESCAPE VEHICLE OWNED AND CUSTOMIZED BY ANDREA ROSEN; A–Z ESCAPE VEHICLE OWNED AND CUSTOMIZED BY ROBERT SHIFFLER,** all 1996. 152 x 102 x 213 cm (each, without wheels); wheels, c. 5 cm; shells: steel, insulation, wood, glass; interiors: mixed media. Installation view "Andrea Zittel: A–Z Escape Vehicles", Andrea Rosen Gallery, New York (NY), USA, 1996.

Münster 1997" she presented floating, brilliant-white groups of seats, which are no longer practical designs but sheer models of longing – like nostalgic Hollywood swinging seats. S. T.

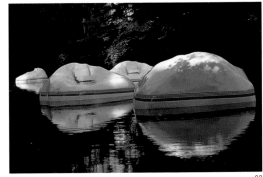

02

◀ 01 / 03

HEIMO ZOBERNIG

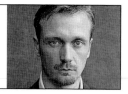

1958 born in Mauthen, Austria / lives and works in Vienna, Austria

An essential aspect of Heimo Zobernig's work is the analysis of the way in which art is presented and its relationship to the development of theories. A clearly defined conceptual framework forms the basis of each of his paintings, sculptures, videos, performances and architectural undertakings, and yet in their execution he is also guided by the given spatial and material conditions. We often notice in Zobernig's objects traces of their genesis. This is worth mentioning because his works frequently show formal similarities with Minimal Art, but by means of deliberate carelessness Zobernig counteracts any aura of solemnity. Furthermore, a large number of his works display a functional use alongside what at first glance appears to be an autonomous sculptural presence. Some of his objects, made from inexpensive materials – paper, cardboard, plaster, chipboard, concrete or polystyrene – are intended for use as furniture and therefore provide the setting for social interaction. His contribution to documenta X was the design of the hall where the "100 Tage 100 Gäste" (100 Days 100 Guests) lectures were held. He designed a low platform and banners bearing the names of the participants. He also sited monitors in the room, fitted all the other technical apparatus into a standard container, and got his artist colleague Franz West to produce the seating. In his poster walls for "Skulptur. Projekte in Münster 1997", Zobernig worked with graphic elements. Here, as often in his work, the utility aspect of his works enters into dialogue with their purely artistic characteristics.

Y. D.

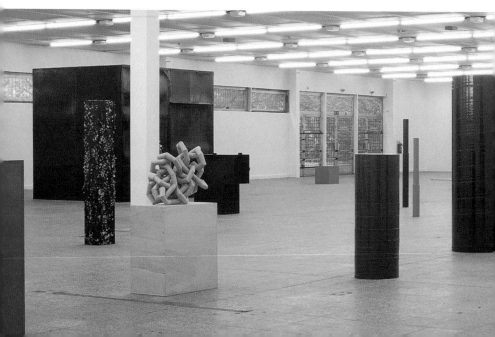

01 INSTALLATION VIEW, INIT-Kunst-Halle Berlin, Berlin, Germany, 1998.
02 UNTITLED, 1994. Acrylic on canvas, 124 x 118 cm. **03 UNTITLED,** 1989. Oil on canvas, 150 x 150 cm.

02 03

◄ 01

APPENDIX

GLOSSARY

APPROPRIATION ART In Appropriation Art, objects, images and texts are lifted from their cultural context and placed unchanged in a new one. They thus become charged with new significance. **ASSEMBLAGE** A three-dimensional picture made of different materials, usually of everyday use. **AURA** The radiance that renders a person or work of art subject to veneration. People or works of art possessing an aura are at once remote and approachable. They fascinate by their precious uniqueness. **AUTONOMY** Condition of self-reliance and independence. In art, autonomy means freedom from any conditioning by non-artistic objectives. **BODY ART** Art that takes the body for its subject and makes it the object of performances, sculptures or videos. **CAMP** Persons or objects whose appearance is exaggeratedly stylised are called camp. Admiration for them generates a mocking and at the same time emotion-laden cult of artificiality. **CATALOGUE RAISONNÉ** Annotated catalogue of an artist's work, with a claim to completeness. **CIBACHROME** A colour print (usually large format) made from a slide. **CODE** Sign system providing the basis for communication and conveying information. **COMPUTER ANIMATION** Apparently three-dimensional models produced on a computer which can be "walked through" or seen from different perspectives by the user; or virtual figures which move on the screen. **COMPUTER-GENERATED** Produced by computer. **CONCEPTUAL ART** Conceptual Art emerged in the 1960s. It gives primacy to the basic idea of a work's content. This is often revealed in language alone, i.e. texts or notes. The actual execution of the work is considered secondary and may be totally lacking. **CONTEXT ART** Context Art criticises the art business and its institutions. Power structures are disclosed, distribution mechanisms and exhibition forms are investigated for their political function. Various artistic means of expression are adopted to present this criticism, such as performances, installations and Object Art. **C-PRINT** A colour print from a photographic negative. **CROSSOVER** Crossover refers to crossing the boundaries between art and popular culture and between different cultures; also to the inclusion of music, design and folklore etc. in artistic work. **CULTURAL STUDIES** A new trend in Anglo-American quasi-academic studies that is concerned with the examination of popular culture. Cultural studies pay particular attention to the influence of ratial, class or gender factors on cultural expression. **CURATOR** A curator decides what exhibitions are about, and selects the participating artists. **DECONSTRUCTION** Deconstruction is a means of interpretation that regards a work not as a closed entity but as an open and many-layered network of the most varied elements in form and content. These elements, their functions and contradictions, are revealed by deconstruction. **DIGITAL ART** Art that makes use of new digital media such as computers and the Internet. **ECLECTICISM** A common resort of Postmodernism, characterised by extensive quotation from largely historical styles and other artists' works. **ENTROPY** A concept derived from heat theory signifying the degree of disorder in closed systems. Total entropy would be reached when a system collapsed in chaos. By analogy, entropy indicates the informational value of news. The ultimate here would be a meaningless rushing noise. **ENVIRONMENT** An

GLOSSARY

interior or exterior space entirely put together by the artist which integrates the viewer in the aesthetic experience. **FICTION** A picture or a story is a fiction when it is based on free invention. **GENDER SURFING** The confusing game with sexual roles whose point is to mix them up, to humorous effect. **GLOBALISATION** Globalisation means that economic or cultural processes increasingly have worldwide implications. **HAPPENING** An artistic action in front of a public that normally becomes involved in what happens. **HETEROGENEITY** Basic difference in kind or species. **HIGH AND LOW (HI 'N' LO)** A complex of themes concerning the influence of trivial culture (low art) on modern art (high art). The concept derives from an exhibition assembled by Kirk Varnedoe in 1990 at the New York Museum of Modern Art. **HYBRID** Of many forms, mixed, incapable of single classification. **ICONOGRAPHY** The language of images or forms that is typical of a particular cultural context; for example, the iconography of advertising, the western, postmodern architecture etc. **ICONOLOGY** The interpretation of the content of a work of art, based on its iconography. **ICON** Image or person venerated by a cult. **INSTALLATION** A work of art that integrates the exhibition space as an aesthetic component. **INTERACTIVE ART** Works of art intended for the viewer's direct participation. Normally this participation is made possible by computer technology. **LOCATION** Site of an event or exhibition etc. **MANGA** Comics and cartoon films, the most popular type of reading matter in Japan, where manga is produced and consumed in large quantitites. **MEMENTO MORI** An event or object reminding one of death. **MINIMAL ART** Art trend of the 1960s that traces scuptures and pictures back to clear basic geometric forms and places them in a concrete relation to the space and the viewer. **MIXED MEDIA** Combination of different media, materials and techniques in the production of a work of art. **MONTAGE** Joining together pictorial elements or sequences in photography, film and video. **MULTIPLE** In the 1960s, the classical concept of a work of art came under fire. Instead of a single original, works of art were produced in longer runs, i.e. as "multiples". The idea was to take art out of museums and galleries and make it more available. **NARRATION** Telling a story in art, film or literature. **NEO-GEO** 1980s style of painting that operates highly objectively with geometric patterns and colour compositions. **NEW AGE** A form of alternative culture that believes in the beginning of a new age. **OBJECT ART** All works of art that contain already existing objects or materials, or are entirely composed of them (cf. readymades). **OP ART** A type of 1960s abstract art that played with optical effects on the eye. **PERFORMANCE** Artistic work performed in public as a (quasi-theatrical) action. The first performances took place during the 1960s in the context of the Fluxus movement, which tried to widen the concept of art. **PHENOMENOLOGY** A branch of philosophy which examines the way external reality appears to humans. **PHOTOSHOP** Computer program that enables pictorial material to be edited. **POLITICAL CORRECTNESS (PC)** A socio-political attitude particularly influential in the USA. The purpose of Political Correctness is to change public language. The principal requirement is to refer to social "minor-

ities" in a non-judgmental way. **POP CULTURE** Pop culture finds its expression in the mass circulation of items from areas such as fashion, music, sport and film. The world of pop culture entered art in the early 60s, through Pop Art. **POST HUMAN** A complex of themes centering on the influence of new technologies – such as computers, genetic engineering etc. – and the influence of a media-based society on the human body. "Post Human" was the title of an exhibition put together by Jeffrey Deitch in 1992. **POSTMODERNISM** Unlike Modernism, Postmodernism starts from the assumption that grand utopias are impossible. It accepts that reality is fragmented and that personal identity is an unstable quantity transmitted by a variety of cultural factors. Postmodernism advocates an irreverent, playful treatment of one's own identity, and a liberal society. **POST-STRUCTURALISM** Whereas Structuralism considers sign systems to be closed, Post-Structuralism assumes that sign systems are always dynamic and open to change (cf. Structuralism). **READYMADES** A readymade is an everyday article which the artist declares to be an artwork and exhibits without major alterations. The idea derives from the French artist Marcel Duchamp, who displayed the first readymades in New York in 1913, e.g. an ordinary urinal or a bottle drier. **REPRESENTATION** The showing of a person, object or condition that fulfils a representative function. **SELF-REFERENTIAL ART** Art that refers exclusively to its own formal qualities and so rejects any idea of portrayal. **SEMANTICS** The study of the significance of linguistic signs, i.e. the meaning of words. **SIMULACRUM** An illusionary image which is so seductive that it can supplant reality. **SOCIAL WORK** Art here is understood as a service that quite deliberately accepts socio-political functions. **STEREOTYPE** A standardised, non-individual image that has become generally accepted. **STILL** A single photograph from a film. **STRUCTURALISM** Structuralism systematically examines the meaning of signs. The purpose of Structuralism is to explore the rules of different sign systems. Languages and even cultural connections are seen and interpreted by Structuralism as sign systems. **TRANSCENDENCY** In philosophy and religion, transcendency is what is beyond normal human perception. In the extraordinary experience of transcendency, therefore, the boundaries of consciousness are crossed. **TRASH** Trash – the US word for "rubbish" – aims at a level below accepted aesthetic and qualititative norms, with ironic intent. **URBANISM** The subject of town construction and living together in towns. **VIRTUAL REALITY** An artificial world created on computer (cf. computer-generated, computer animation). Hence a 'virtual' street, house etc. **WHITE CUBE** The neutral white exhibition room which in modern times has succeeded older forms of presenting art, e.g. hanging of pictures close to each other on coloured wallpaper. The white cube is supposed to facilitate the concentrated and undisturbed perception of the work of art. **YOUNG BRITISH ARTISTS (YBA)** Group of young British artists who since the beginning of the 1990s have created a furore with object and video art inspired by pop culture. R. S., J. V.

PHOTO CREDITS

Unless otherwise specified, copyright on the works reproduced lies with the respective artists. **ACKERMANN,** Franz: Portrait: © Albrecht Fuchs, Cologne; 01: © Albrecht Fuchs, Cologne; Courtesy Neuer Aachener Kunstverein, Aachen, Germany; 02: Courtesy neugerriemschneider, Berlin **AHTILA,** Eija-Liisa: 01–02: © VG Bild-Kunst, Bonn, Germany, 2001; © Crystal Eye Ltd., Helsinki, Finland; Courtesy Klemens Gasser & Tanja Grunert Inc., New York **ALTHOFF,** Kai: 01: Courtesy Galerie NEU, Berlin; 02: Photo: Lothar Schnepf, Cologne; Collection of Daniel Buchholz, Cologne **ARAKI,** Nobuyoshi: 01–02: © Nobuyoshi Araki and © Jens Rathmann, Hamburg **BARNEY,** Matthew: 01–03: Courtesy Barbara Gladstone Gallery, New York; 01: Photo: Michael James O'Brien; © 1994 Matthew Barney; 02: Photo: Michael James O'Brien; © 1997 Matthew Barney; 03: Larry Lame **BEECROFT,** Vanessa: Portrait: Photo: Armin Lanke; 01–02: Courtesy Deitch Projects, New York; 01: Photo: Vanessa Beecroft **BONIN,** Cosima von: 01–03: Courtesy Galerie Christian Nagel, Cologne; 01: Photo: J. Brasille; 03: © Andrea Stappert, Berlin **BULLOCH,** Angela: 01: Photo: Mancia/Bodmer; © FBM studio, Zurich; Courtesy Galerie Hauser & Wirth 2, Zurich; Collection of Südwest LB, Stuttgart, Germany, Michael Trier, Cologne, Migros Museum für Gegenwartskunst Zürich, Zurich **CATTELAN,** Maurizio: 01: Photo: Maranzano; Courtesy Minini, Brescia, Italy; 02: © Roman Mensing; Courtesy Westfälisches Landesmuseum, Münster, Germany **CHAPMAN,** Jake & Dinos: 01, 03: Courtesy Victoria Miro Gallery, London; 02: Photo © Stephen White; Boros Collection **CURRIN,** John: Portrait: Courtesy Andrea Rosen Gallery, New York; 01–02: Courtesy Andrea Rosen Gallery, New York; 01: Photo: Marc Domage/ Tutti; 02: Photo: Fred Scruton **DELVOYE,** Wim: 01: Collection Delfina, London; 04: Collection of Museum of Sculpture Middelheim, Antwerp **DEMAND,** Thomas: Portrait: © Christian Borchert; 01–02: © VG Bild-Kunst, Bonn, Germany, 2001; Courtesy Victoria Miro Gallery, London; 01: © Thomas Demand 1997; 02: © Thomas Demand 1994 **DIJKSTRA,** Rineke: Portrait: Photo: Paul Andriesse, Amsterdam; Courtesy Galerie Paul Andriesse, Amsterdam; 01–07: Courtesy Galerie Paul Andriesse, Amsterdam **DION,** Mark: Portrait: Photo: Georg Kargl, Vienna, 1994; Courtesy Georg Kargl, Vienna; 01–03: Courtesy American Fine Arts, Co., Colin de Land Fine Art, New York **EDMIER,** Keith: 01–02: Courtesy Friedrich Petzel Gallery, New York **ELIASSON,** Olafur: 01–04: Courtesy Kunsthalle Basel, Basle; 05: Photo: Ingrid Nilsson; © Malmö Museer, Malmö, Sweden; Courtesy Tanya Bonakdar Gallery, New York **EMIN,** Tracey: Portrait: Photo: Johnnie Shand-Kydd; Courtesy Jay Jopling, London; 01–02 Photo: Stephen White; Courtesy Jay Jopling, London; **FLEURY,** Sylvie: 01: Courtesy Galerie Mehdi Chouakri, Berlin, and Migros Museum für Gegenwartskunst Zürich, Zurich; 02: © Stefan Rötheli, Zurich; Courtesy Bob van Orsouw Gallery, Zurich, Galerie Mehdi Chouakri, Berlin, and Migros Museum für Gegenwartskunst Zürich, Zurich **FÖRG,** Günther: Portrait: Courtesy Galerie Max Hetzler, Berlin; 01: Courtesy Galerie Max Hetzler, Berlin; Private collection, Cologne; 02: Photo: Rudolf Nagel **FRITSCH,** Katharina: 01–02: © VG Bild-Kunst, Bonn, Germany, 2001; 01–02: Courtesy Matthew Marks Gallery, New York; 01: Photo: Nic Tenwiggenhorn, Düsseldorf; 02: Photo: Nic Tenwiggenhorn, Düsseldorf; Dauerleihgabe der Dresdner Bank, Frankfurt/M., an das Museum für Moderne Kunst, Frankfurt/M. **GENZKEN,** Isa: 01–02: Courtesy Galerie Daniel Buchholz, Cologne; 01: Photo: Werner Kaligofsky; 02: Burda Collection, Baden-Baden, Germany **GILLICK,** Liam: Portrait: Courtesy Robert Prime, London; 01: Courtesy Schipper & Krome, Berlin; 02: Sammlung FER **GOLDIN,** Nan: Portrait: © Christine Fenzl; 01–03: © Nan Goldin, New York; 04: Courtesy Matthew Marks Gallery, New York **GONZALEZ-TORRES,** Felix: Portrait: David Seidner © 1994; Courtesy Andrea Rosen Gallery, New York; 01–04: Courtesy Andrea Rosen Gallery, New York; 01: Exhibition by EV + A Administration; 02: Photo: Peter Muscato; 03: Photo: Cal Kowal; 04: Photo: Stefan Rohner **GORDON,** Douglas: Portrait: Photo: Martijn Van Nieuwenhuyzen, Amsterdam; Courtesy Lisson Gallery, London; 01–04: Courtesy Lisson Gallery, London; 01: Collection of Centre Georges Pompidou, Paris; 02: Photo: Heidi Kosaniuk, Glasgow, Scotland; 03: Photo: Marcus Leith; 04: Photo: Cary Markerink, Amsterdam; Collection of Stedelijk Museum, Amsterdam **GURSKY,** Andreas: Portrait: Photo: Wiebke Langefeld; © Kunstmuseum Wolfsburg, Wolfsburg, Germany; 01–02: © VG Bild-Kunst, Bonn, Germany, 2001; Courtesy Monika Sprüth Galerie, Cologne **HALLEY,** Peter: Portrait: © Vittorio Santoro, Zurich; 01, 03: Courtesy Jablonka Galerie, Cologne **HEROLD,** Georg: Portrait: © Rudi Bergmann; 01–02: © VG Bild-Kunst, Bonn, Germany, 2001; 01: Photo: E. P. Prokop; 02: Photo: Uwe H. Seyl **HILL,** Gary: Portrait: Photo: Marine Hugonnier; Courtesy Donald Young Gallery, Chicago; 01–03: Courtesy Donald Young Gallery, Chicago; 03: Photo: Mark B. McLoughlin **HÖFER,** Candida: Portrait: Photo: Ralph Müller; 01–02: © VG Bild-Kunst, Bonn, Germany, 2001 **HÖLLER,** Carsten: Portrait: Photo: Curtis Anderson; 01–04: © VG Bild-Kunst, Bonn, Germany, 2001; 01: Photo: Matthias Herrmann, Vienna; Courtesy Schipper & Krome, Berlin; 02: Courtesy Schipper & Krome, Berlin; 03: Courtesy Air de Paris, Paris; Collection of Eileen and Michael Cohen, New York **HOLZER,** Jenny: Portrait: Photo: John Deane; 01–02: © VG Bild-Kunst, Bonn, Germany, 2001; Courtesy of Jenny Holzer Studio, New York; © 1998 by Jenny Holzer; 01: Photo: David Heald; 02: Photo: Hans-Dieter Kluge; © Förderkreis der Leipziger, Leipzig, Germany **HORN,** Roni: Portrait: © Kurt Wyss, Basle; 01–02: Courtesy Jablonka Galerie, Cologne **HUME,** Gary: Portrait: © Justin Westover, London; Courtesy Jay Jopling, London; 01–04: Photo: Stephen White; Courtesy Jay Jopling, London **HUYGHE,** Pierre: Portrait: Photo: Laurent Godin; © Galerie Roger Pailhas, Marseille; 01–02: Courtesy Galerie Roger Pailhas, Marseille, France; 01: Collection of Musée d'Art Moderne de la Ville de Paris, Paris **JAKOBSEN,** Henrik Plenge: 01–03: Courtesy of Galleri Nicolai Wallner, Copenhagen, Denmark; 01: Photo: Henrik Plenge Jakobsen **KELLEY,** Mike: Portrait: Photo: Fredrik Nilson; 01: Courtesy of the artist and Metro Pictures, New York; 02: Courtesy Jablonka Galerie, Cologne **KIPPENBERGER,** Martin: Portrait: © Elfie Semotan, Vienna; 01–02: © The Estate of Martin Kippenberger; Courtesy Galerie Gisela Capitain, Cologne; 02: Private collection **KOONS,** Jeff: 01–02: © Jeff Koons; All photographs are courtesy of the artist **KRUGER,** Barbara: 01: Photo © Zindman/Fremont; Courtesy Mary Boone Gallery, New York; 02: Courtesy Galerie Monika Sprüth, Cologne; 02: Photo: Tom Powel; Courtesy Deitch Projects, New York **LAND,** Peter: 01–04: Courtesy of Galleri Nicolai Wallner, Copenhagen, Denmark **LAWLER,** Louise: 02, 04: Courtesy of the artist and Metro Pictures, New York; 03, 05: Courtesy Galerie Monika Sprüth, Cologne **LEONARD,** Zoe: Portrait: Photo: © Jack Louth, 1997; Courtesy Paula Cooper Gallery, New York; Photo: Markus Tollhopf; 03–04: Courtesy Galerie Gisela Capitain, Cologne **VAN LIESHOUT,** Atelier: Portrait: © D. J. Wooldrik; © 1998, c/o Beeldrecht Amstelveen; 01–03: © VG Bild-Kunst, Bonn, Germany, 2001; © 1998, c/o Beeldrecht Amstelveen; Courtesy Fons Welters Gallery, Amsterdam 01: Photo: D. J. Wooldrik & van Lieshout; CAST Collection, Tilburg; 02: Photo: D. J. Wooldrik; CAST Collection, Tilburg, The Netherlands; 03: Photo: D. J. Wooldrik **LOCKHART,** Sharon: 01–02: Courtesy neugerriemschneider, Berlin **LUCAS,** Sarah: Portrait: © the Artist; Courtesy Sadie Coles HQ, London; 01–03: © the Artist; Courtesy Sadie Coles HQ, London **MAJERUS,** Michel: Portrait: © Albrecht

BIOGRAPHICAL NOTES ON THE AUTHORS

LARS BANG LARSEN / L. B. L. (*1972): Studied literature and art history; lives and works in Copenhagen as a freelance critic and curator for the Danish Contemporary Art Foundation.

CHRISTOPH BLASE / C. B. (*1956): Studied communication sciences in Munich; lives and works in Berlin as a freelance art journalist; publications in *Frankfurter Allgemeine Zeitung, Kunst-Bulletin, Focus* etc; editor of the Internet page "Blitz Review" (http://blitzreview.thing.at).

YILMAZ DZIEWIOR / Y. D. (*1964): Studied art history; lives and works in Cologne as a freelance critic and curator; publications in *Artforum, Texte zur Kunst, neue bildende kunst*, etc.

JEAN-MICHEL RIBETTES / J.-M. R. (*1951): Studied linguistics and jurisprudence; lives and works in Paris as a psychoanalyst, art critic and freelance curator; teaches at the Ecole Nationale des Arts Appliqués, Duperré, Paris.

RAIMAR STANGE / R. S. (*1960): Studied philosophy, literature and journalism; lives and works in Berlin as a freelance art publicist and curator; publications in *Kunst-Bulletin, Flash-Art, Artist*, etc.

SUSANNE TITZ / S. T. (*1964): Studied art history, history, philology and literature; since 1997 director of the Neuer Aachener Kunstverein; has organised seminars on the development of art and art theory since the sixties.

JAN VERWOERT / J. V. (*1972): Did cultural studies and philosophy in Hildesheim and London: works as a freelance art critic; publications in *Springerin, Parkett, neue bildende kunst*, etc.

ASTRID WEGE / A. W. (*1965): Did cultural studies in Hildesheim; since 1995, editor at *Texte zur Kunst*; publications in *Artis, Flash Art, documents, Texte zur Kunst* etc.

IMPRINT

To stay informed about upcoming TASCHEN titles, please
request our magazine at www.taschen.com or write to
TASCHEN America, 6671 Sunset Boulevard, Suite 1508,
USA–Los Angeles, CA 90028, Fax: +1-323-463 4442.
We will be happy to send you a free copy of our magazine
which is filled with information about all of our books.
© 2001 **TASCHEN GMBH**
Hohenzollernring 53, D–50672 Köln
© **FOR THE ILLUSTRATIONS** by Eija-Liisa Ahtila, Thomas
Demand, Katharina Fritsch, Andreas Gursky, Georg Herold,
Carsten Höller, Jenny Holzer, Joep van Lieshout, Thomas Ruff,
Gregor Schneider, Rosemarie Trockel, Heimo Zobernig:
VG Bild-Kunst, Bonn, 2001
TEXTS Lars Bang Larsen, Christoph Blase, Yilmaz Dziewior,
Jean-Michel Ribettes, Raimar Stange, Susanne Titz,
Jan Verwoert, Astrid Wege
DESIGN Andy Disl **PRODUCTION** Ute Wachendorf
EDITING AND COORDINATION Nina Schmidt
ENGLISH TRANSLATION John Mitchell
COVER DESIGN Angelika Taschen, Claudia Frey

Printed in Italy
ISBN 3-8228-1160-2

Art Now Vol. 2
Ed. Uta Grosenick / Flexi-cover,
604 pp. / € 29.99 / $ 39.99 /
£ 19.99 / ¥ 5.900

Woman Artists
Ed. Uta Grosenick / Flexi-cover,
192 pp. / € 6.99 / $ 9.99 /
£ 4.99 / ¥ 1.500

"An essential reference book, *Art Now* is a must-have!"

—*Kultureflash*, London

"Buy them all and add some pleasure to your life."

African Style
Ed. Angelika Taschen

Alchemy & Mysticism
Alexander Roob

All-American Ads 40ˢ
Ed. Jim Heimann

All-American Ads 50ˢ
Ed. Jim Heimann

All-American Ads 60ˢ
Ed. Jim Heimann

American Indian
Dr. Sonja Schierle

Angels
Gilles Néret

Architecture Now!
Ed. Philip Jodidio

Art Now
Eds. Burkhard Riemschneider,
Uta Grosenick

Atget's Paris
Ed. Hans Christian Adam

Berlin Style
Ed. Angelika Taschen

Cars of the 50s
Ed. Jim Heimann, Tony
Thacker

Cars of the 60s
Ed. Jim Heimann, Tony
Thacker

Cars of the 70s
Ed. Jim Heimann, Tony
Thacker

Chairs
Charlotte & Peter Fiell

Christmas
Ed. Jim Heimann, Steven Heller

Classic Rock Covers
Ed. Michael Ochs

Design Handbook
Charlotte & Peter Fiell

Design of the 20ᵗʰ Century
Charlotte & Peter Fiell

Design for the 21ˢᵗ Century
Charlotte & Peter Fiell

Devils
Gilles Néret

Digital Beauties
Ed. Julius Wiedemann

Robert Doisneau
Ed. Jean-Claude Gautrand

East German Design
Ralf Ulrich / Photos: Ernst Hedler

Egypt Style
Ed. Angelika Taschen

Encyclopaedia Anatomica
Ed. Museo La Specola
Florence

M.C. Escher

Fashion
Ed. The Kyoto Costume
Institute

Fashion Now!
Ed. Terry Jones, Susie Rushton

Fruit
Ed. George Brookshaw,
Uta Pellgrü-Gagel

HR Giger
HR Giger

Grand Tour
Harry Seidler

Graphic Design
Eds. Charlotte & Peter Fiell

Greece Style
Ed. Angelika Taschen

Halloween
Ed. Jim Heimann, Steven
Heller

Havana Style
Ed. Angelika Taschen

Homo Art
Gilles Néret

Hot Rods
Ed. Coco Shinomiya, Tony
Thacker

Hula
Ed. Jim Heimann

Indian Style
Ed. Angelika Taschen

India Bazaar
Samantha Harrison, Bari Kumar

Industrial Design
Charlotte & Peter Fiell

Japanese Beauties
Ed. Alex Gross

Krazy Kids' Food
Eds. Steve Roden,
Dan Goodsell

Las Vegas
Ed. Jim Heimann,
W. R. Wilkerson III

London Style
Ed. Angelika Taschen

Mexicana
Ed. Jim Heimann

Mexico Style
Ed. Angelika Taschen

Morocco Style
Ed. Angelika Taschen

New York Style
Ed. Angelika Taschen

Paris Style
Ed. Angelika Taschen

Penguin
Frans Lanting

20ᵗʰ Century Photography
Museum Ludwig Cologne

Photo Icons I
Hans-Michael Koetzle

Photo Icons II
Hans-Michael Koetzle

Pierre et Gilles
Eric Troncy

Provence Style
Ed. Angelika Taschen

Robots & Spaceships
Ed. Teruhisa Kitahara

Safari Style
Ed. Angelika Taschen

Seaside Style
Ed. Angelika Taschen

Albertus Seba. Butterflies
Irmgard Müsch

**Albertus Seba. Shells &
Corals**
Irmgard Müsch

Signs
Ed. Julius Wiedeman

South African Style
Ed. Angelika Taschen

Starck
Philippe Starck

Surfing
Ed. Jim Heimann

Sweden Style
Ed. Angelika Taschen

Sydney Style
Ed. Angelika Taschen

Tattoos
Ed. Henk Schiffmacher

Tiffany
Jacob Baal-Teshuva

Tiki Style
Sven Kirsten

Tuscany Style
Ed. Angelika Taschen

Valentines
Ed. Jim Heimann,
Steven Heller

Web Design: Best Studios
Ed. Julius Wiedemann

Web Design: Flash Sites
Ed. Julius Wiedemann

Web Design: Portfolios
Ed. Julius Wiedemann

**Women Artists
in the 20ᵗʰ and 21ˢᵗ Century**
Ed. Uta Grosenick